La Jolla

A PHOTOGRAPHIC JOURNEY

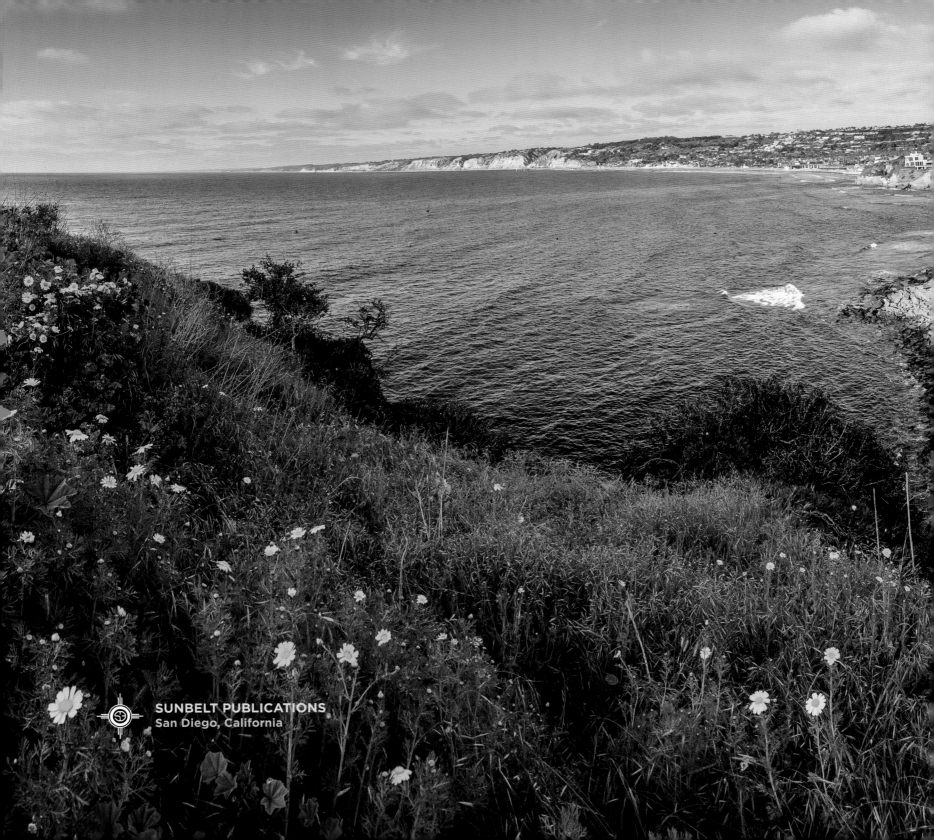

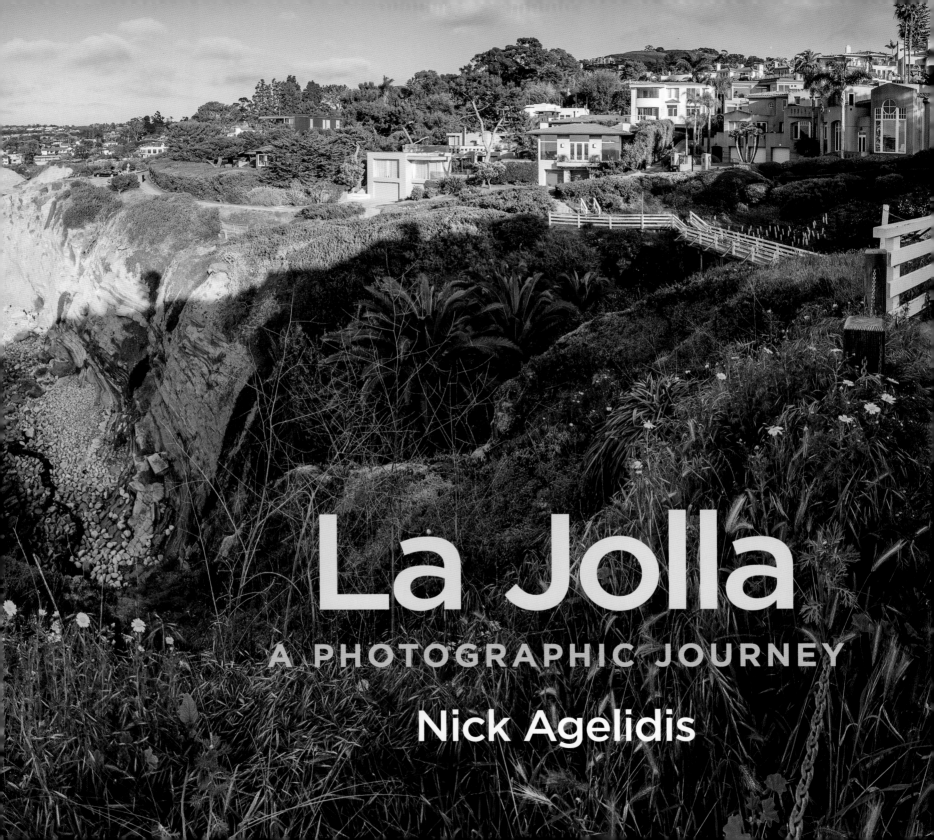

La Jolla
A PHOTOGRAPHIC JOURNEY

Nick Agelidis

La Jolla: A Photographic Journey

Sunbelt Publications, Inc.
Copyright © 2014 by Nick Agelidis
All rights reserved. First edition 2014

Book design by Lydia D'moch
Project management by Deborah Young
Printed in China

Sunbelt Publications, Inc.
P.O. Box 191126
San Diego, CA 92159-1126
(619) 258-4911, fax: (619) 258-4916
www.sunbeltbooks.com

17 16 15 14 5 4 3 2 1

All photographs by Nick Agelidis

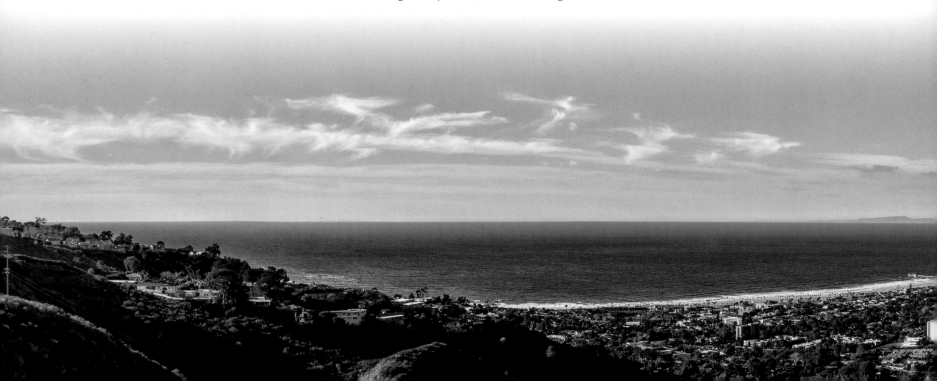

Below: Mt. Soledad provides expansive panoramas of San Diego County,
such as this one looking north past La Jolla Shores along the California coast.

To Lamya, Alex, and Yasmine

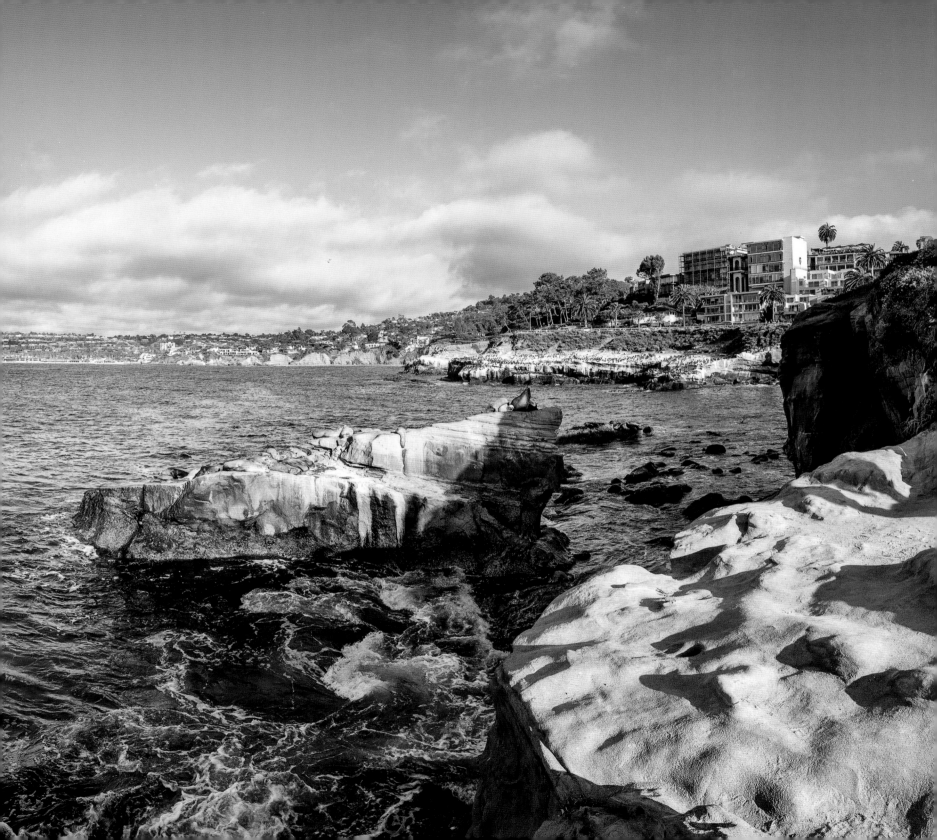

Preface

Visitors from across the United States and the world flock to La Jolla to enjoy its unique combination of natural beauty, diverse wildlife, and exceptional climate. Fortunate ones may have the opportunity to live there. Over the years it has bred or attracted more than its fair share of literary and entertainment figures, scientists, academics, politicians, and successful entrepreneurs.

Underpinning La Jolla's enduring appeal is its multitude of natural charms. Mount Soledad, protruding into the Pacific Ocean from the broad arc of the southern California coastline, has created a range of distinctive physical features: sweeping vistas from the mountain; the northeast-facing protected beach at La Jolla Cove; the wide sandy beach at La Jolla Shores; sheer high cliffs along Torrey Pines; a labyrinth of sea caves along the coast at La Jolla Caves; rocky outcrops separating secluded sandy pockets along Windansea; and tide pools dotted along the coast. Even seals and pelicans find it inviting.

Tourists have been coming to La Jolla since the 1890s when the arrival of the railroad prompted developers to construct coastal resorts along its shores. The generosity of newspaper heiress Ellen Browning Scripps during the 1920s helped transform La Jolla into a cultural center and artist colony. Growth in subsequent years was boosted by the end of each of the World Wars, as many returning servicemen came to settle permanently. The town grew to a population of 17,000 by 1960, and over 40,000 today, as new subdivisions expanded outwards from the original center and up the slopes of the surrounding hills.

It is no surprise that La Jolla continues to flourish as a vibrant and sophisticated town. In addition to drawing in beach lovers, nature enthusiasts, and fun seekers, La Jolla has become a magnet for culture and the arts, and boasts world-renowned

Sea lions and tourists are attracted to Point La Jolla
where they can enjoy the views of the Pacific coastline.

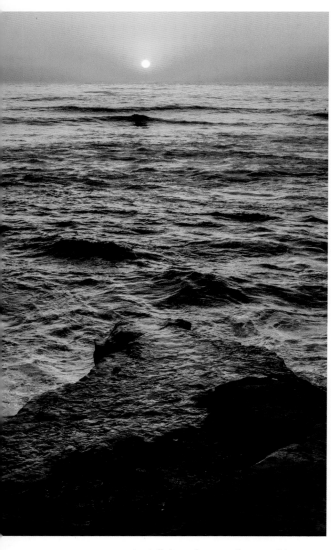

La Jolla's rocky coastline provides an ever-changing canvas of light and shadow; a rocky outcrop at Shell Beach points to the setting sun.

research and academic institutions. Its array of exclusive homes, upscale shops, and fine restaurants are a testament to La Jolla's enduring appeal.

As a new resident of La Jolla, I remember nodding in agreement when I learned that its name originated from the Spanish *La Joya* ("the jewel")—it made perfect sense. More recently, I discovered that there is some dispute among historians and that the name may, in fact, be derived from the Indian *Woholle* ("hole in the mountains") or Mexican Spanish *joya* or *hoya* ("a hollow on the coast worn by waves") or Kumeyaay *matku-laahuuy* ("place that has holes or caves")—all very plausible based on the coastal caves in the area. A jewel or a hole? These alternative interpretations seem to represent the emotional and logical sides of the debate, both of which, as an engineer turned photographer, I can appreciate. However, regardless of the correct answer, which we may never know for sure, La Jolla will always be "the jewel" in my mind.

I have lived and worked in various locations around the world and found something to appreciate in all of them. But when the opportunity of a relatively early retirement presented itself, my wife and I re-acquainted ourselves with La Jolla and made the easy decision to move here. It seemed to embody many of the best aspects of the various places we had lived.

Many hectic years in corporate roles in technical and general management had granted me little time for more creative pursuits. I had been an enthusiastic photographer for many years, but with more time on my hands, I was able to turn my part-time hobby into a full-time passion. Now, a day without my camera feels like an opportunity missed.

I am fortunate to live in a beautiful part of the world that affords wonderful photographic opportunities, and each day I try either to capture an interesting image or to learn something new—and most days I succeed. My preference is travel photography, but La Jolla is so breathtaking that, even while at home, I feel like I'm on vacation every day.

This book is a collection of images from the first few months of exploring my new neighborhood. I have attempted to capture both La Jolla's magnificent natural setting and some of the interesting and quirky features of the town itself. As a photographer, I strive to create images that allow the inherent beauty of the

subject to come through. I find that beauty can be enjoyed at the large or small scale: in the interplay of colors, or sometimes when the color is drained away; or in the juxtaposition of images that reflect a common theme or an interesting contrast. You will find a combination of these approaches throughout this book. Yet typically, I want the subject matter, composition, vantage point, and ambient conditions to take center stage.

I hope I am able to convey through my photographs the delight that a recent La Jollan has discovered in his newfound surroundings and to remind visitors and current residents of the pleasures they have experienced in the Jewel.

Acknowledgments

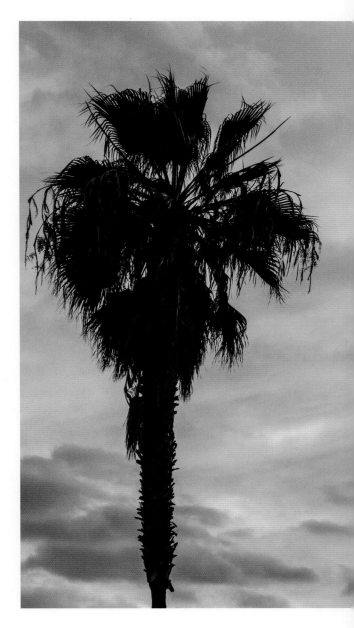

What started as a collection of photos to document my beautiful new surroundings for my own pleasure has turned into a book that I hope others can enjoy. For that, I have several people to thank: my wife, Lamya, for encouraging me to take this to the next level; my daughter, Yasmine, whose good eye I could rely on for constructive and discriminating critique; Diana Lindsay at Sunbelt Publications, who saw value in the project and offered many useful suggestions along the way; Debi Young, who guided me through the publishing process and put up with a newcomer's expectations; Lydia D'moch, the book designer, who took something I was originally quite proud of and showed me how much better it could be; the staff at Warwick's for their suggestions and helpful insights about the La Jolla scene; Philip Unitt, the Curator of the Department of Birds and Mammals at the San Diego Natural History Museum, for his advice on the local fauna; and the residents of La Jolla, humans and animals alike, who probably often wondered what this guy with the camera was doing day after day.

—*Nick Agelidis*
February 2014

Santa Ana winds can produce striking pastel-colored sunsets, such as the one silhouetting a palm tree in the Village.

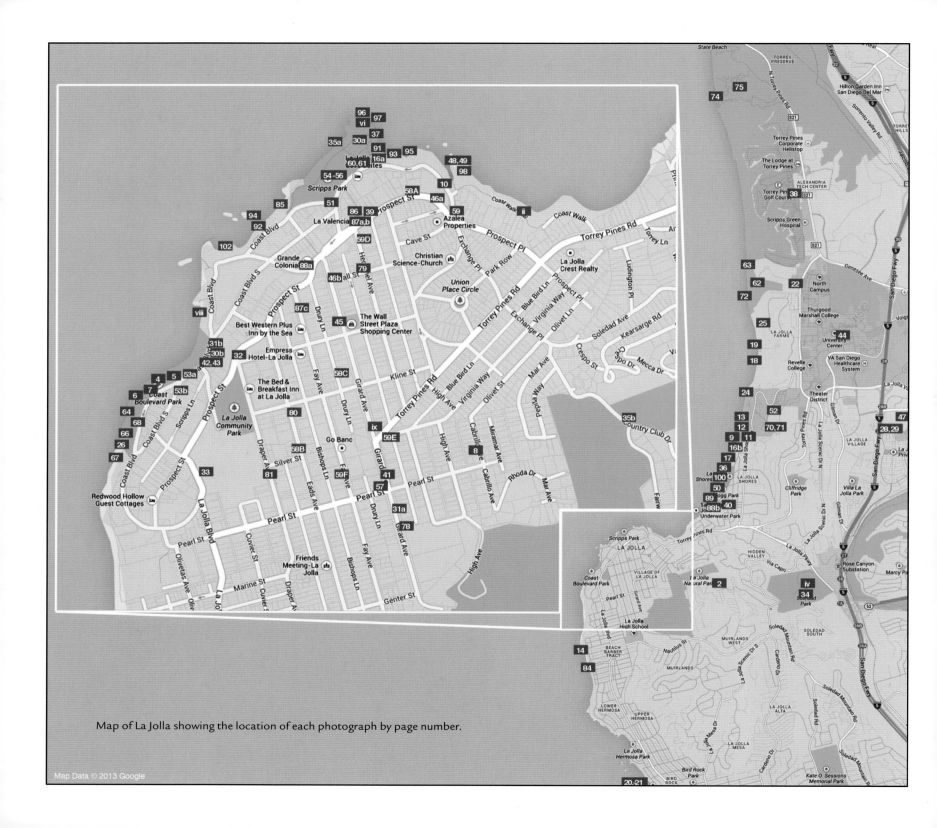

Map of La Jolla showing the location of each photograph by page number.

La Jolla

A PHOTOGRAPHIC JOURNEY

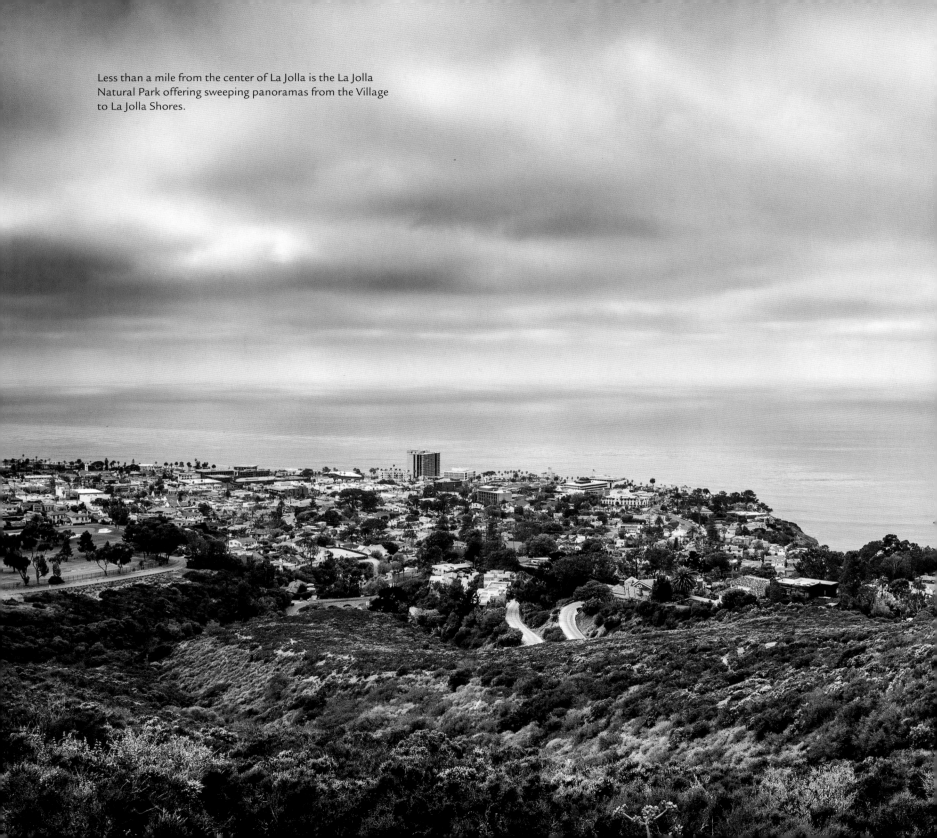

Less than a mile from the center of La Jolla is the La Jolla Natural Park offering sweeping panoramas from the Village to La Jolla Shores.

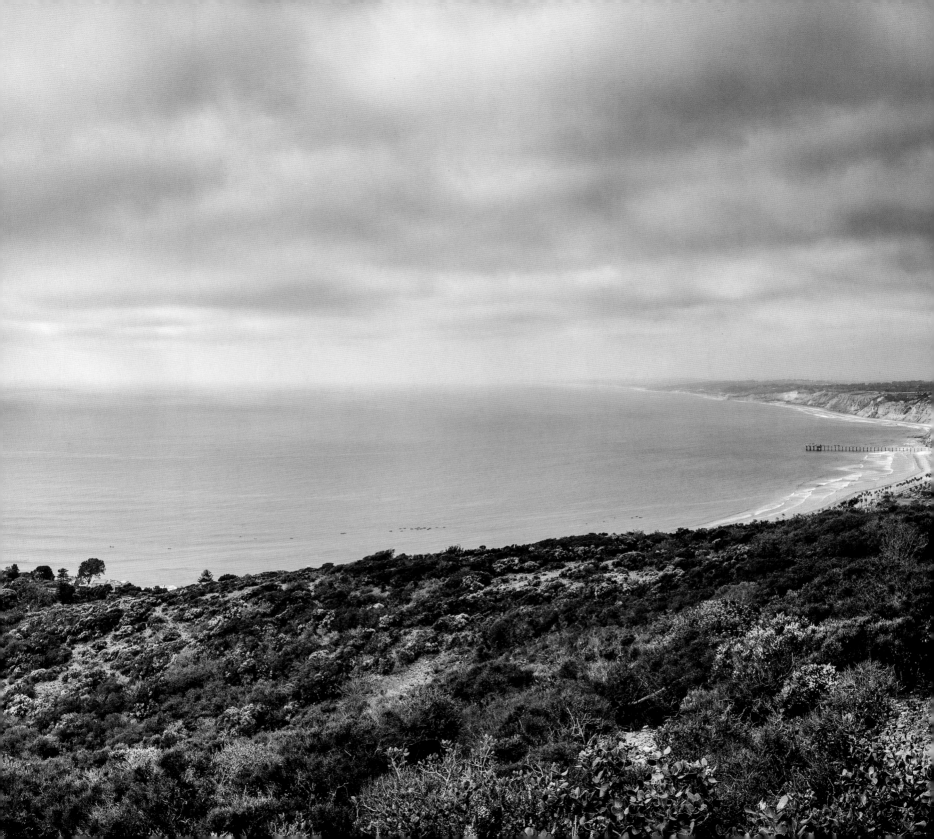

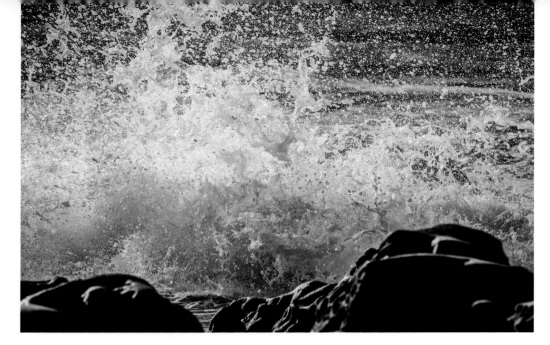

The power of the sea is evident as waves crash onto the rocks at Hospitals creating, over time, multiple small tide pools along the shore.

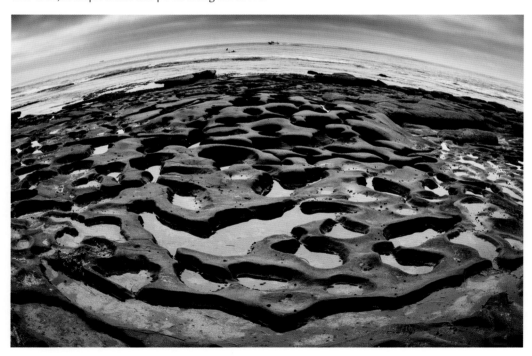

An early morning view toward the Village from across the algae-covered rocks at Hospitals.

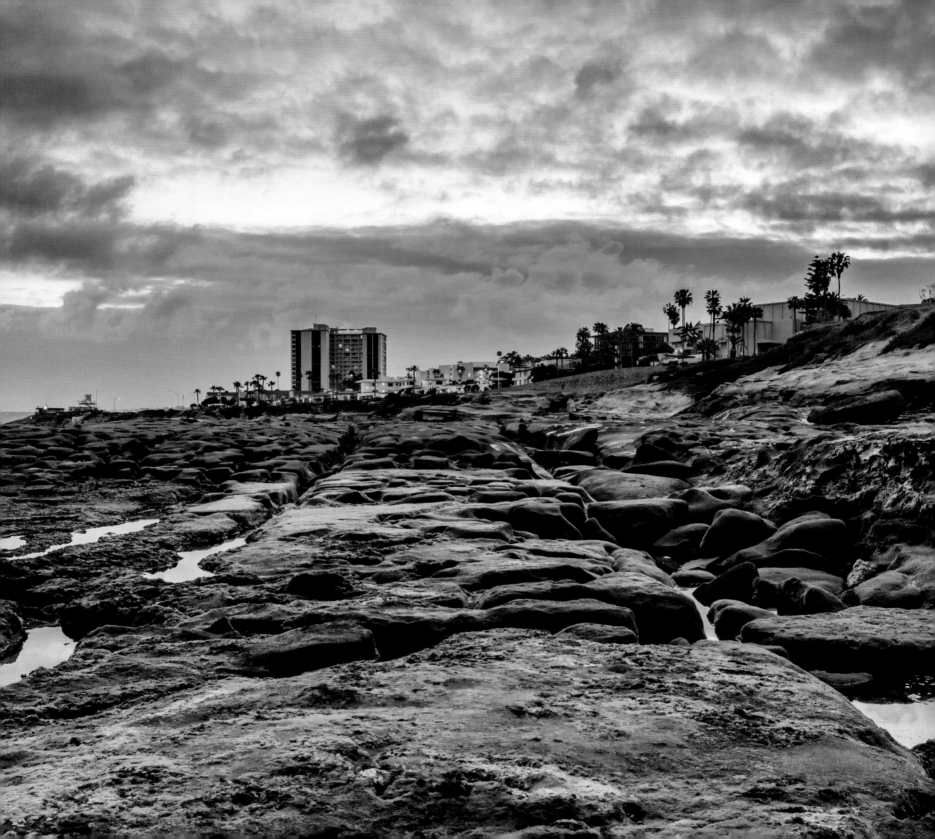

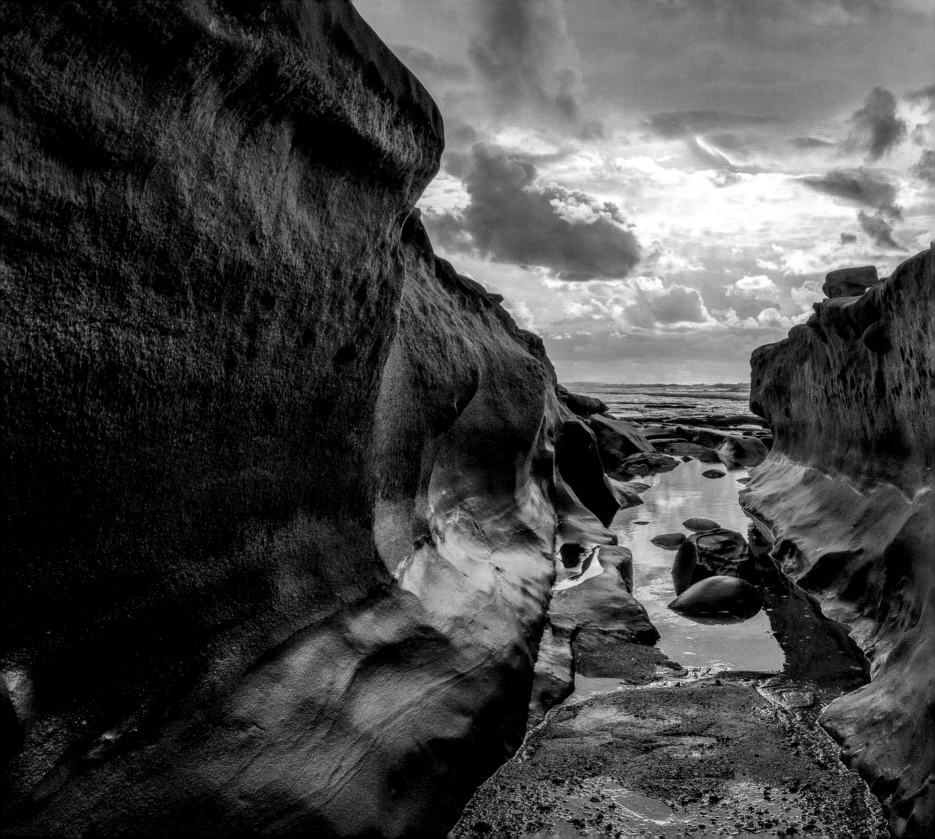

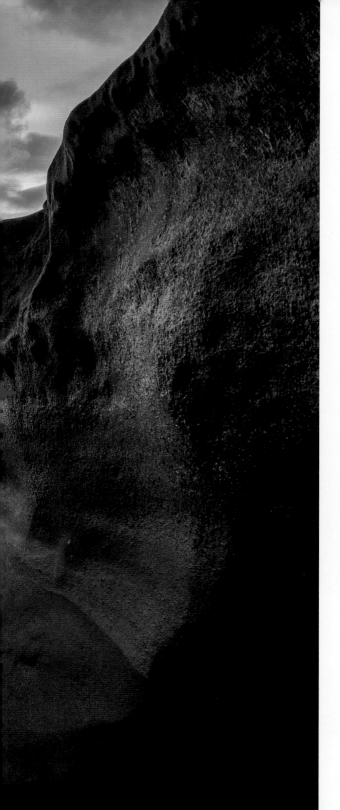

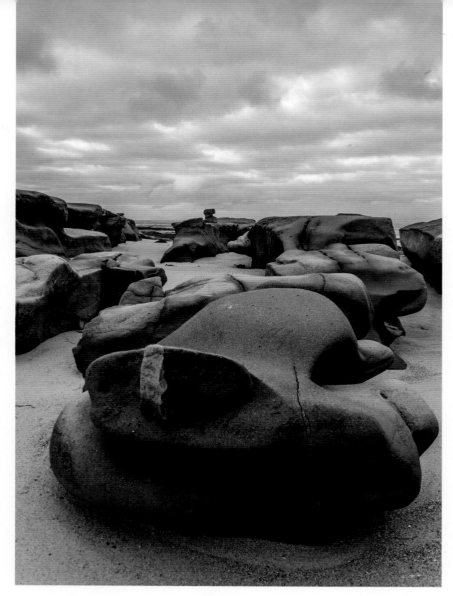

The alien-looking rocks that dot the shore at Hospitals
were created by millennia of pounding surf.

The rocky shore at Hospitals has fissures running towards the
southwest. Smoothed out by the waves and covered in green
algae, these channels provide a dramatic vantage point as the
sun emerges from the clouds after an afternoon thunderstorm.

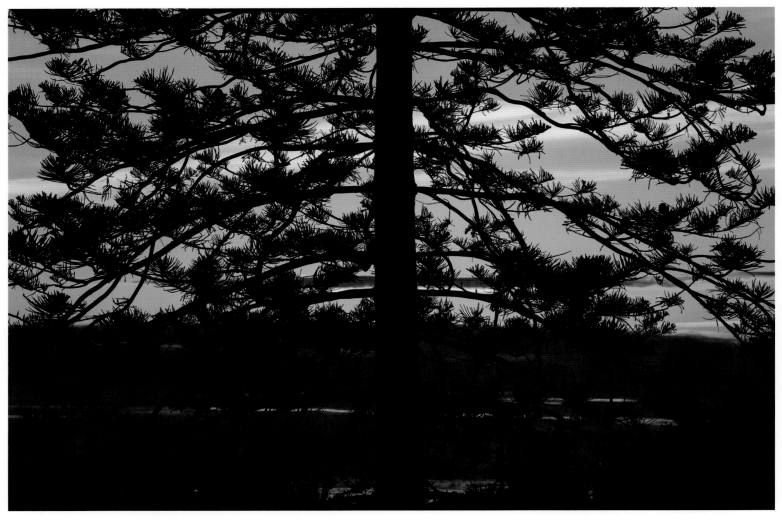

Spectacular sunsets are frequent, whether silhouetting a neighborhood pine tree or tempting a surfer for one more ride.

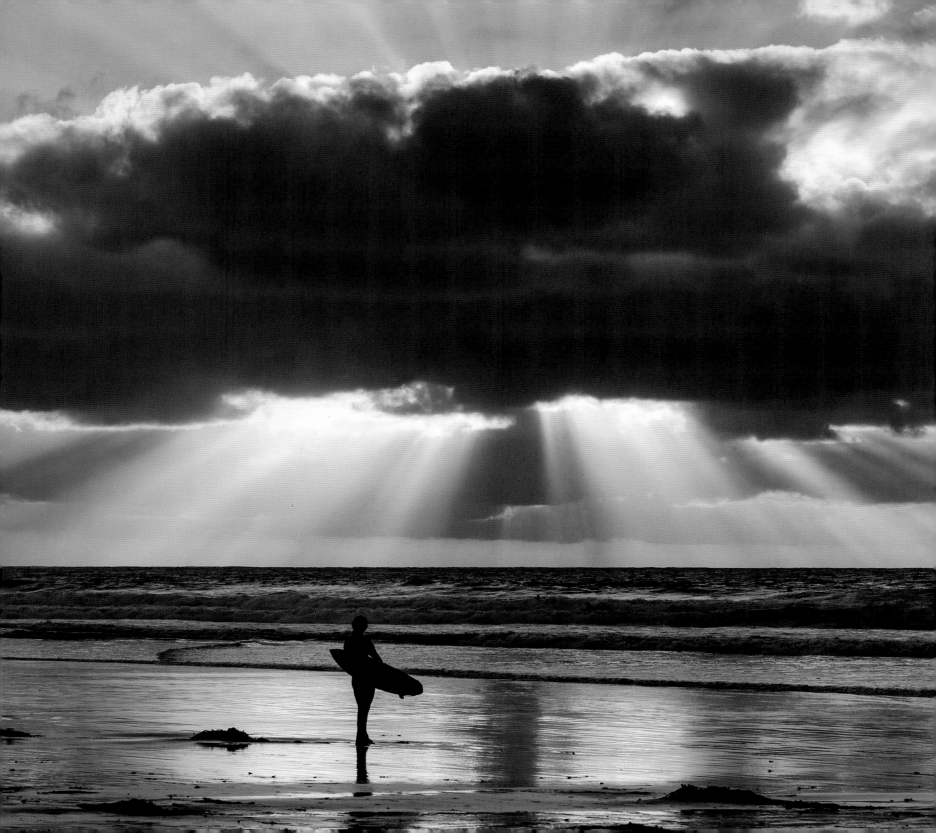

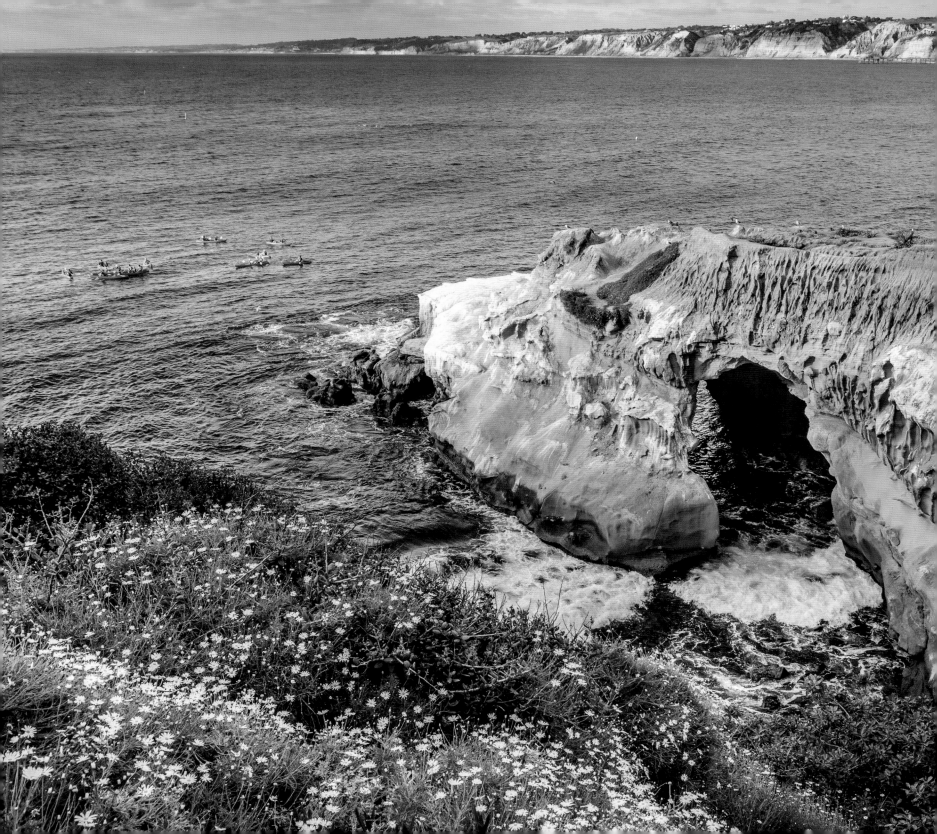

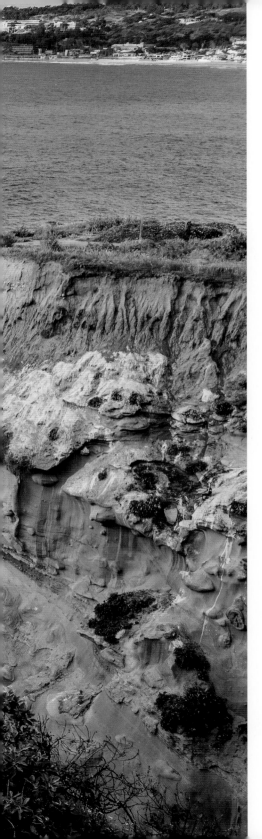

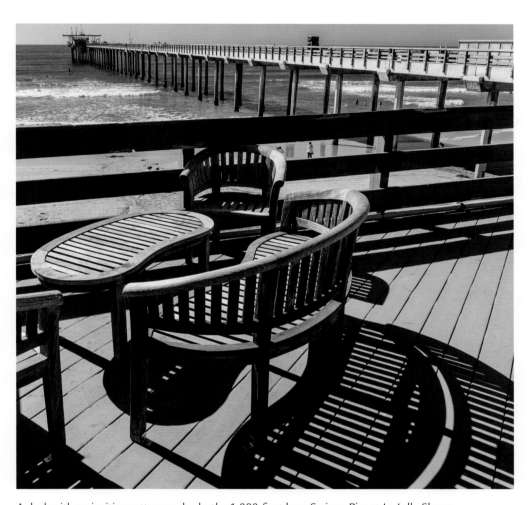

A deck with an inviting settee overlooks the 1,000-foot long Scripps Pier at La Jolla Shores.

Goldfish Point, the cavernous arched promontory
housing the Sunny Jim Cave, juts out into La Jolla Bay.

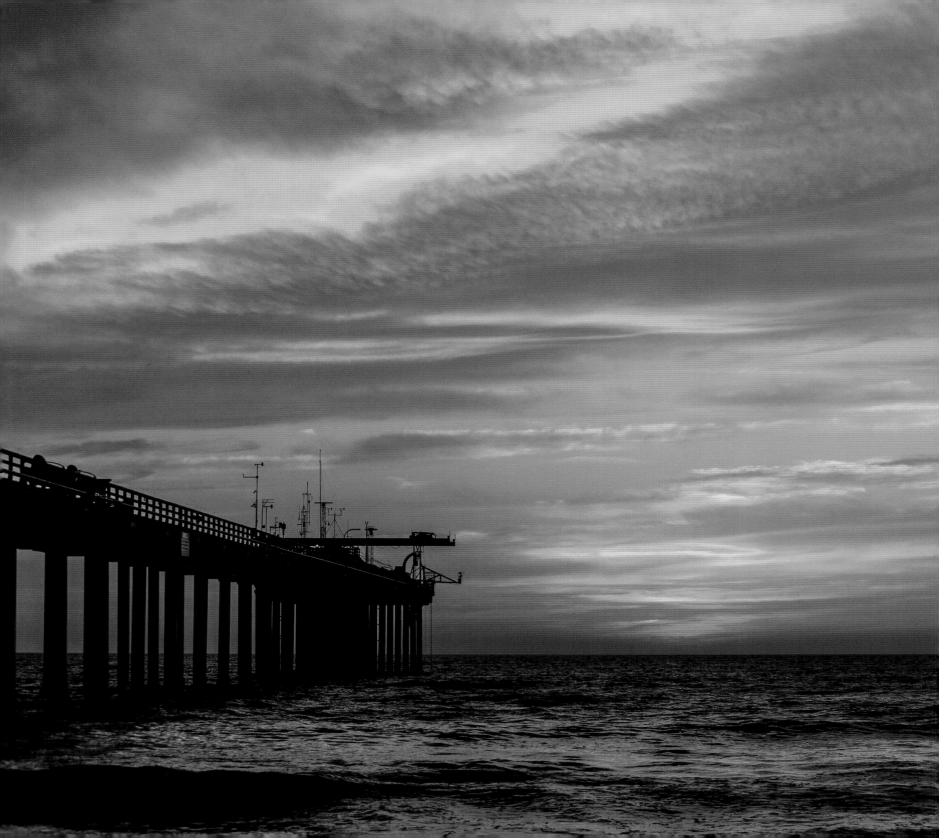

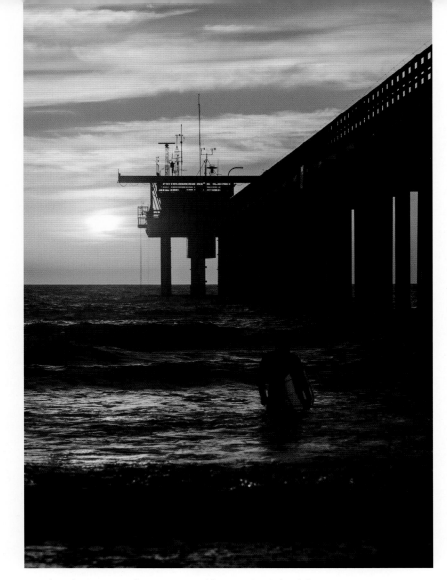

Another glorious La Jolla sunset provides a majestic backdrop to the silhouette of the Scripps Pier.

Following pages: Brown pelicans are ever-present around La Jolla and can often be seen in large flocks. Here they display admirable discipline and coordination as they follow their leader in a long drawn-out line skimming the water at Windansea Beach.

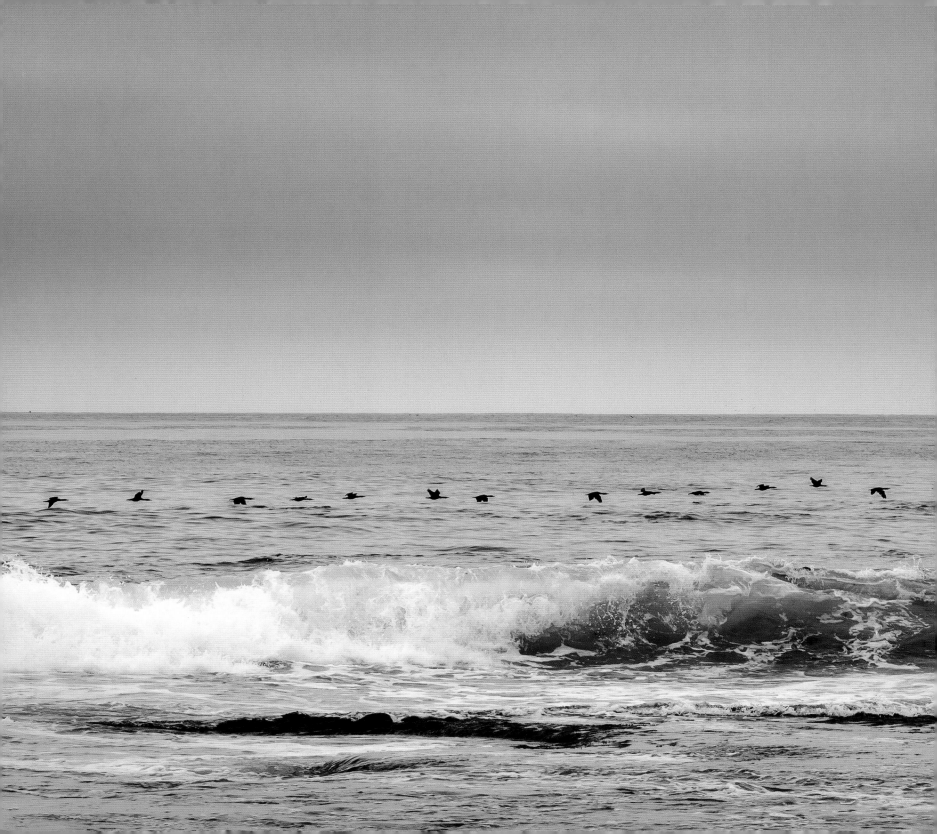

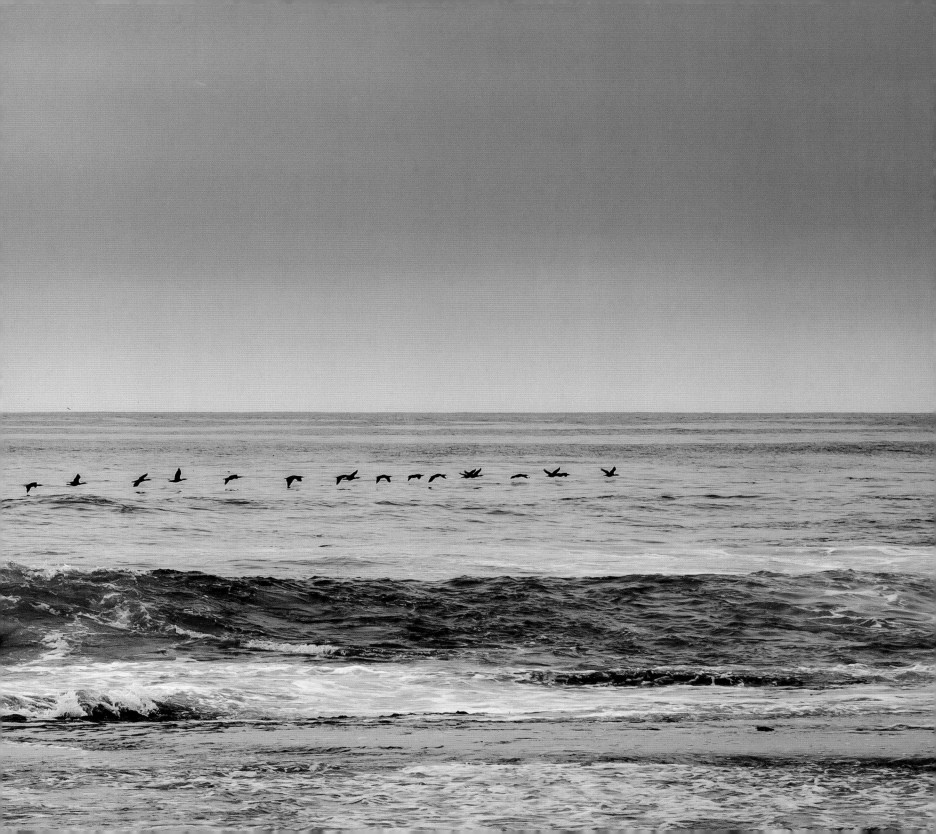

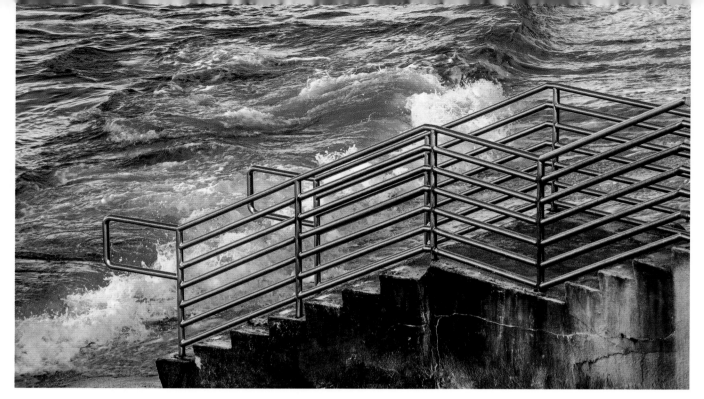

The linear man-made forms of metal and wood contrast with the fluid movement
of the sea at a staircase at the Cove and at Scripps Pier in La Jolla Shores.

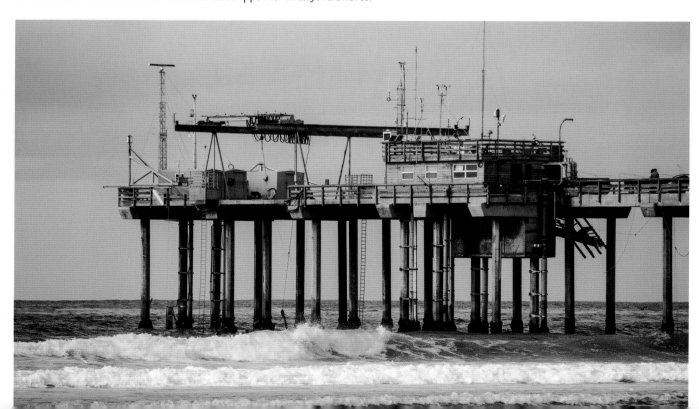

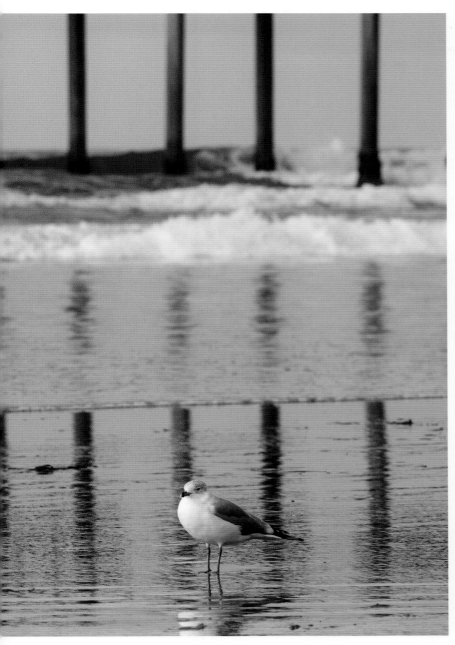

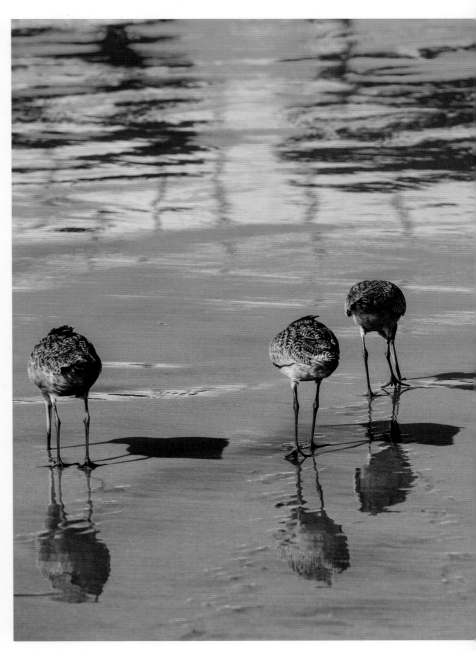

Local seabirds go about their daily business of looking for food in the shallow waters of La Jolla Shores, oblivious to the Scripps Pier reflected in the water.

A stroll along the beach near La Jolla Shores can reward the observant visitor with beautiful abstract patterns in the sand.

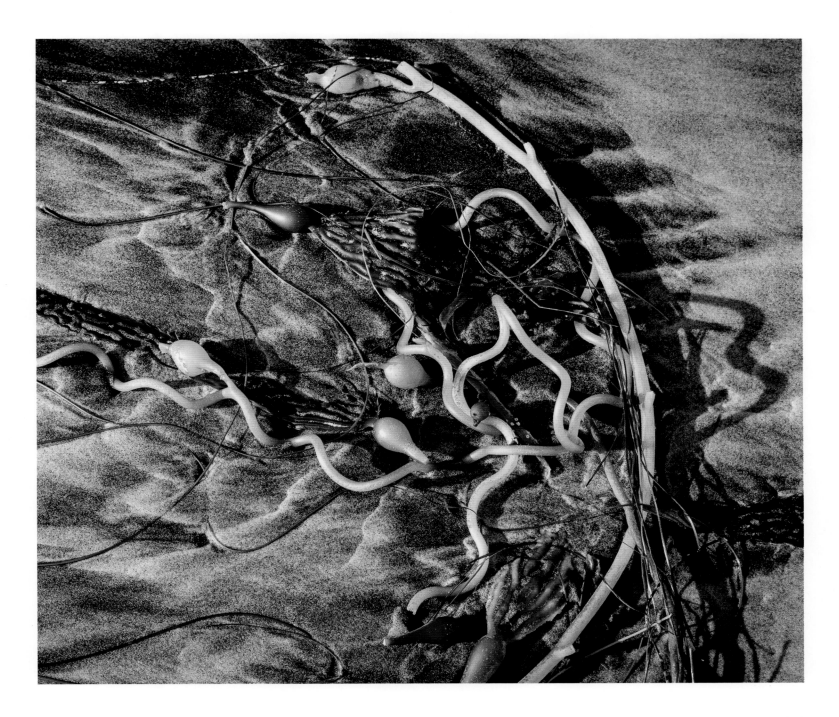

Aquatic plants and sea creatures exposed by the low tide await the ocean's return near Bird Rock.

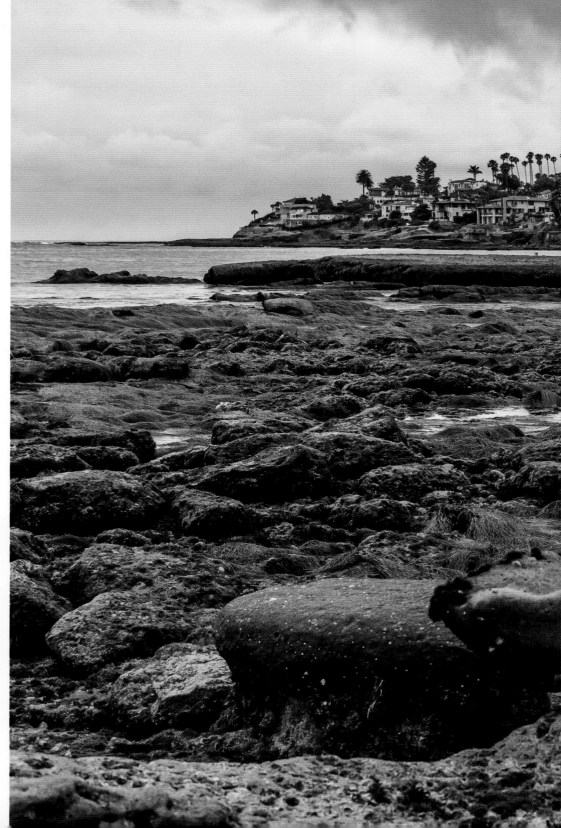

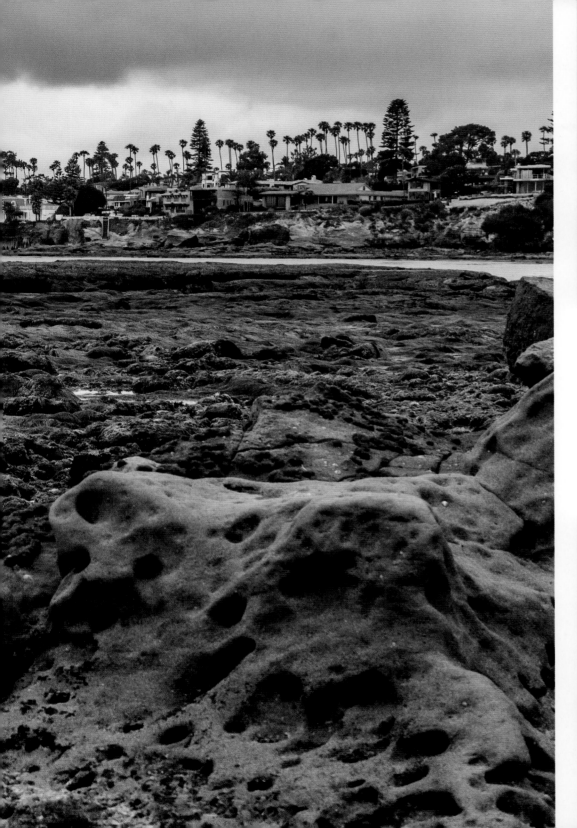

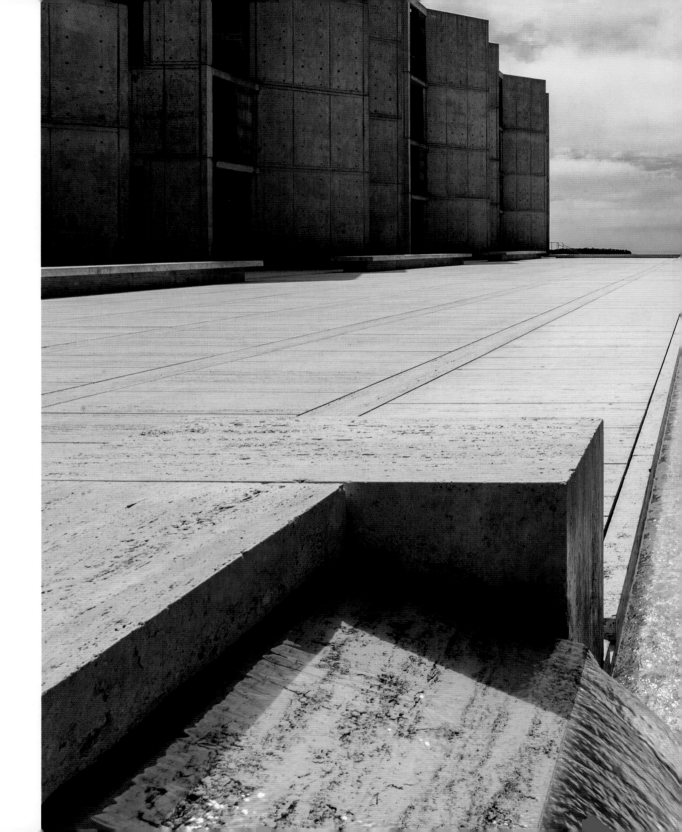

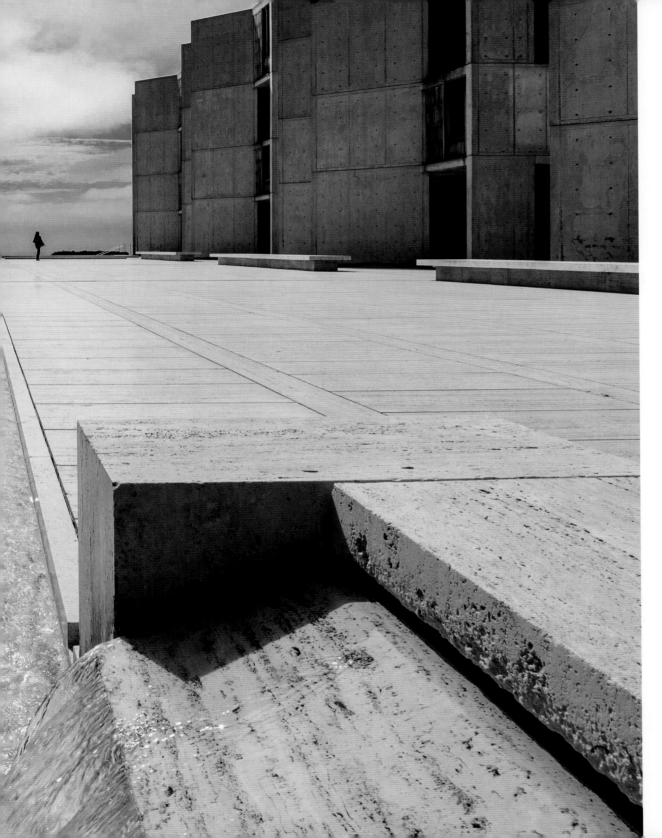

Louis Kahn created striking architectural forms at the world-renowned Salk Institute for Biological Studies.

23

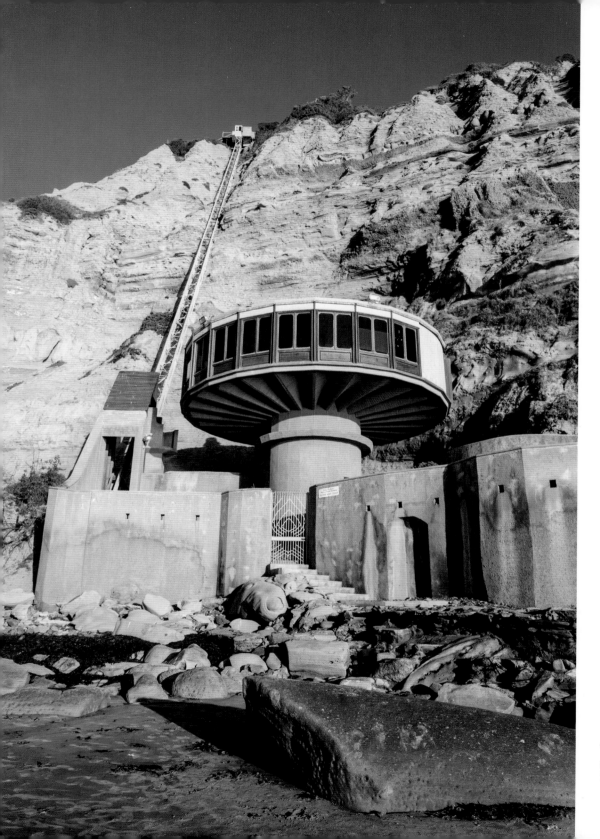

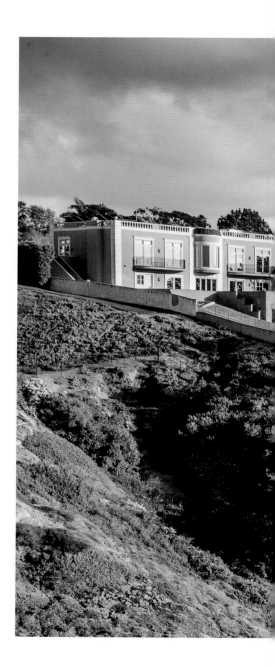

The Pavilion (aka "the Mushroom"), built in 1968, sits on Black's Beach at the bottom of an almost 300-foot tramway ride down from street level.

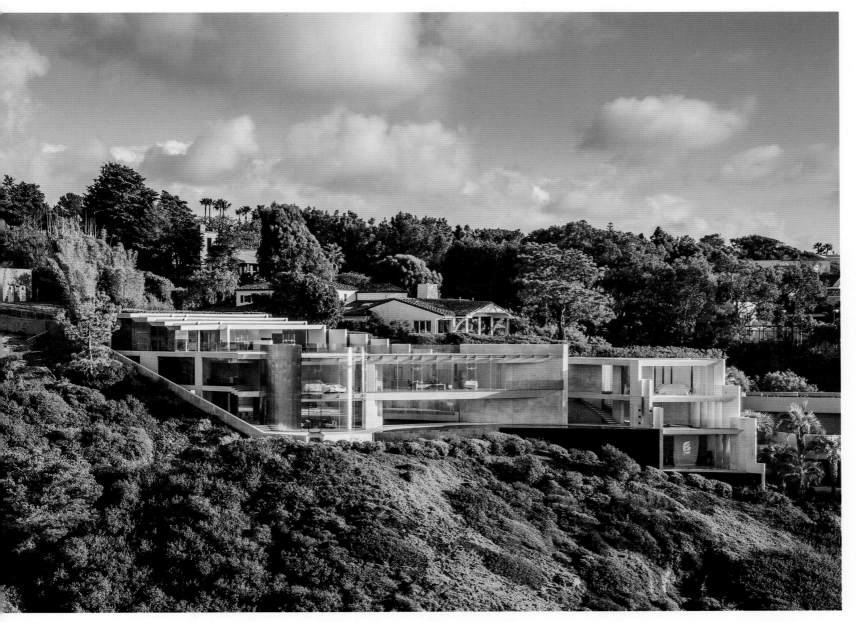

La Jolla is home to many exclusive and unusual houses, such as "The Razor"—a cutting edge residence in the exclusive La Jolla Farms area.

Following pages: Dramatic clouds cause a blue glow to settle over Nicholson Point shortly after sunset.

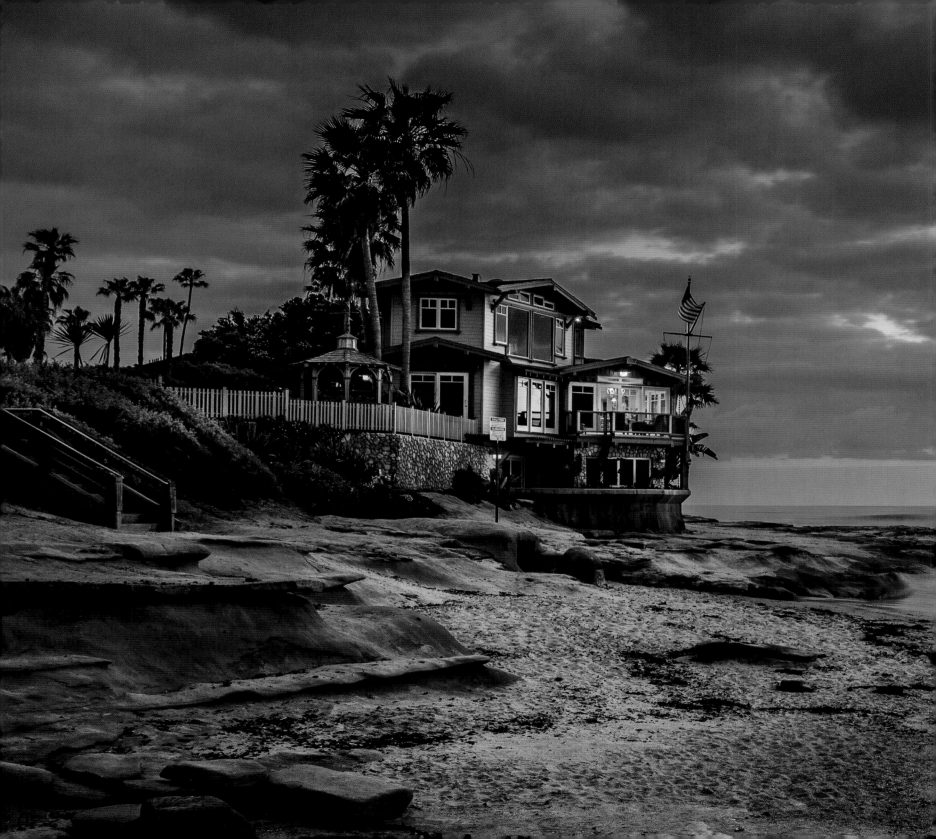

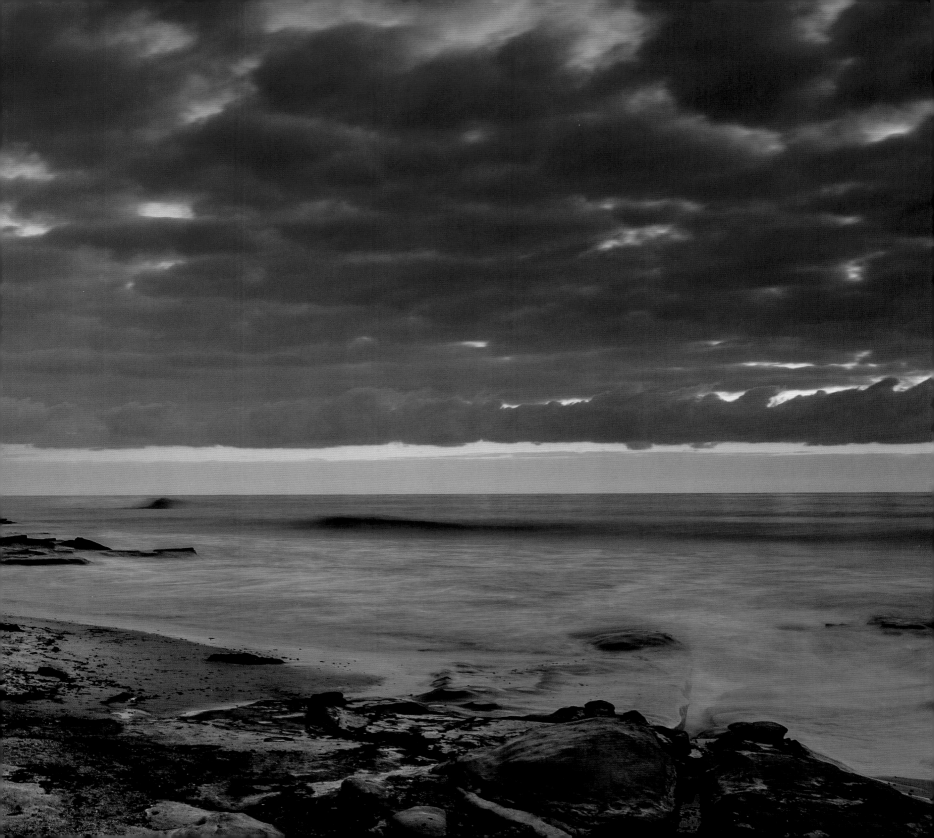

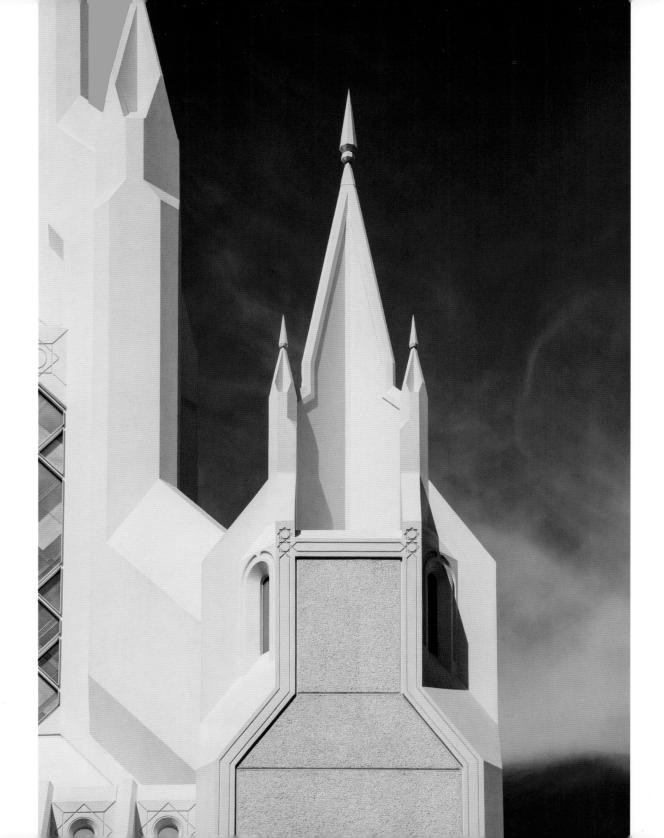

28

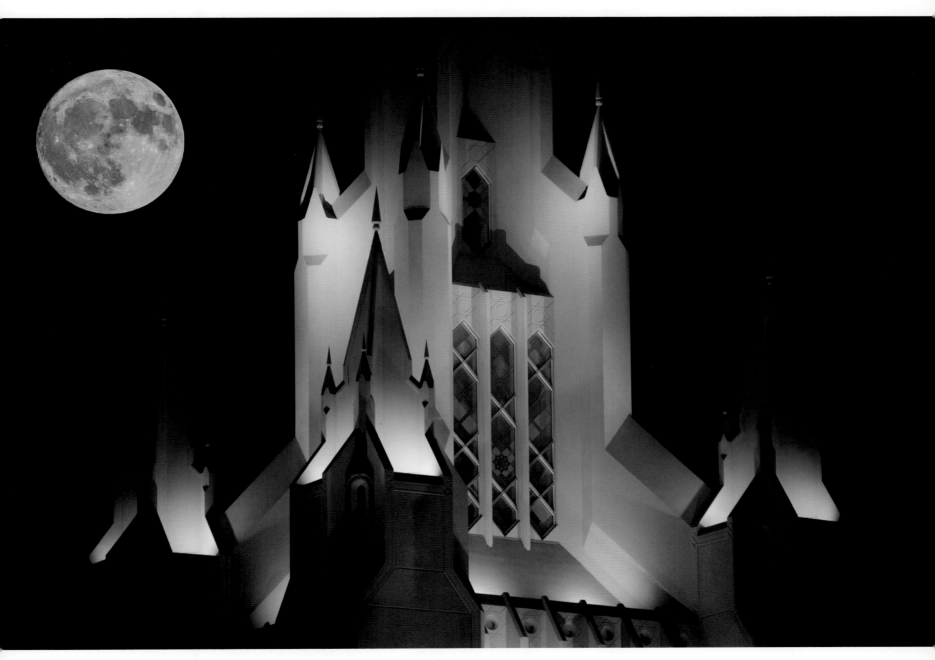

The Mormon Temple stands mythical and mysterious, whether day or night.

Repeating forms: a tree in Ellen Browning Scripps Park and a modern art installation at the San Diego Museum of Contemporary Art in La Jolla.

 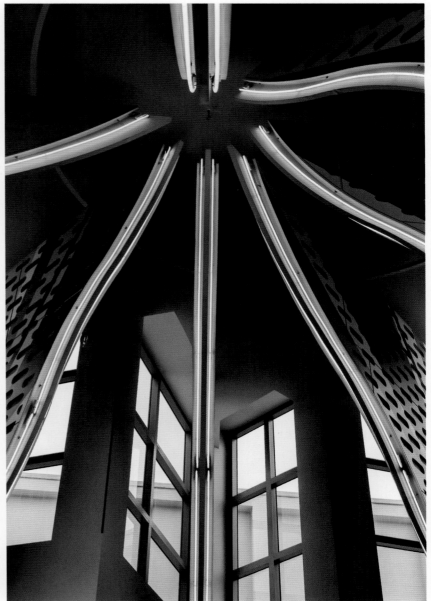

Repeating forms: rustic street art in the Village and the ceiling of the San Diego Museum of Contemporary Art.

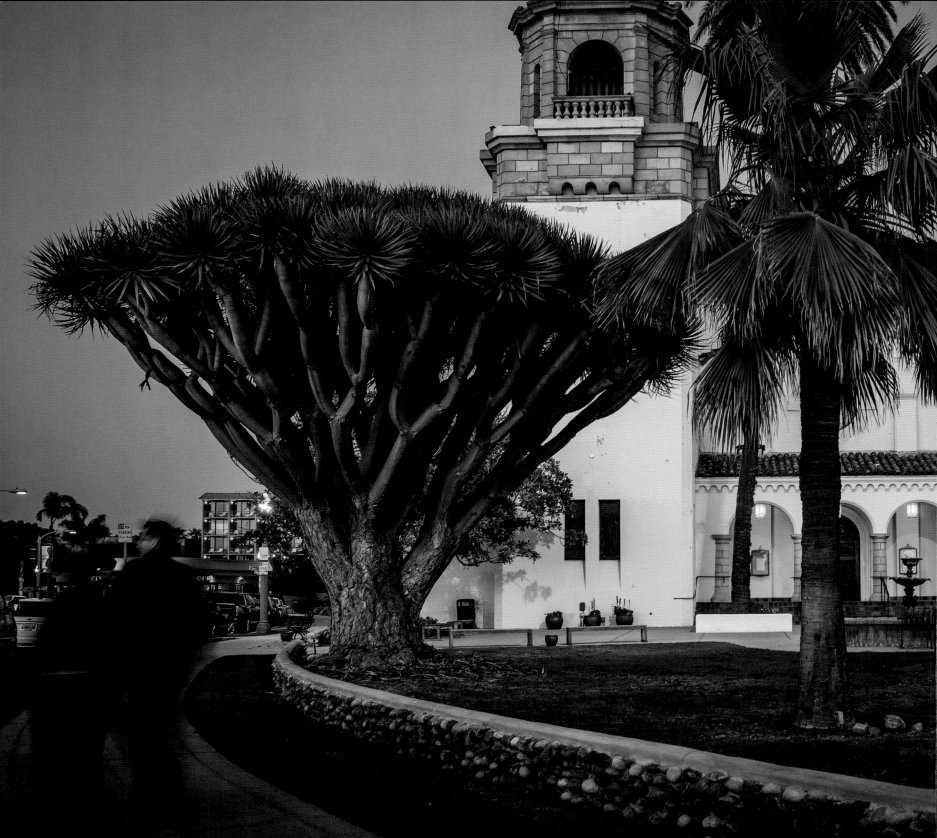

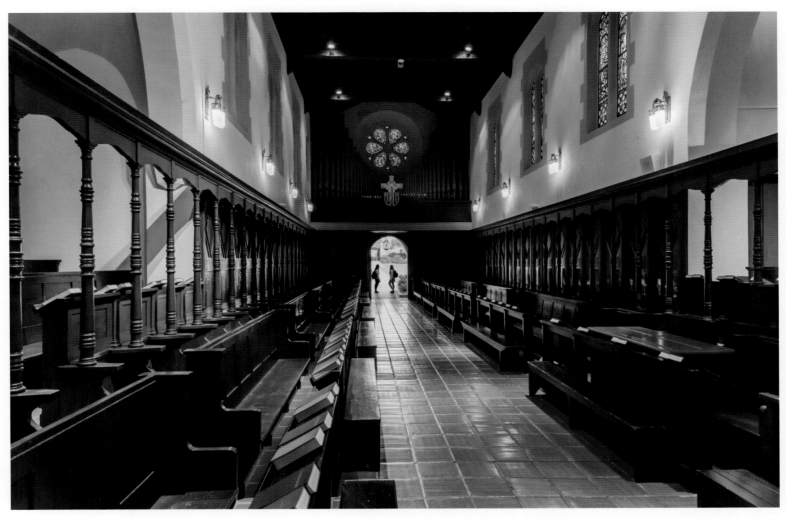

St. Mary's Chapel at The Bishop's School was founded in 1909.

The last rays of sun shine on St. James by-the-Sea Episcopal Church
at dusk as a couple head into the Village.

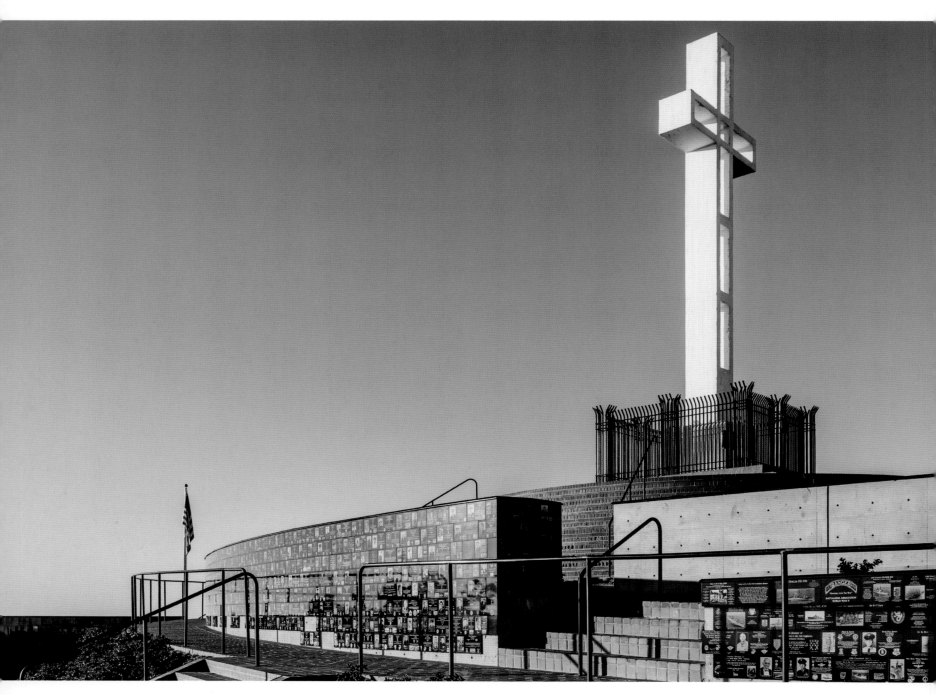

The Veterans Memorial sits atop Mt. Soledad surrounded by granite plaques with the names of honorees.

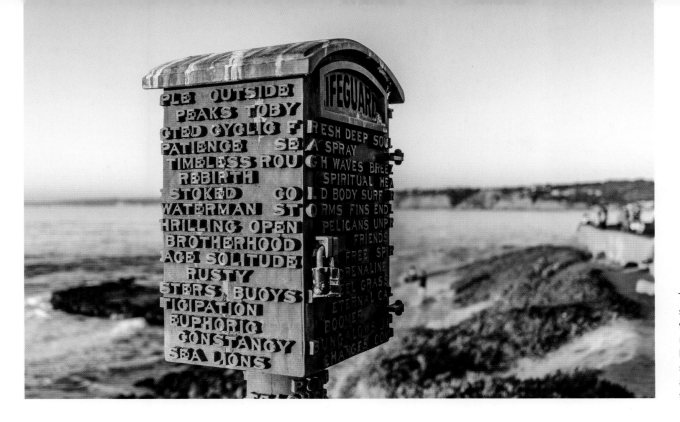

The lifeguard box stands near the Cove with an inscription in memory of David C. Freeman, a drowned surfer whose name appears vertically on the door.

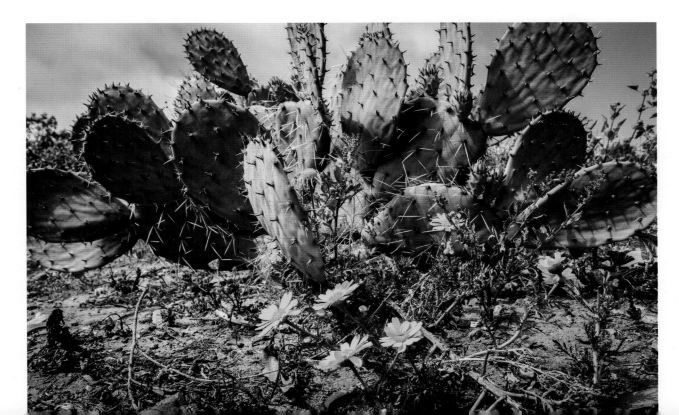

Cacti grow wild in the La Jolla Natural Park.

35

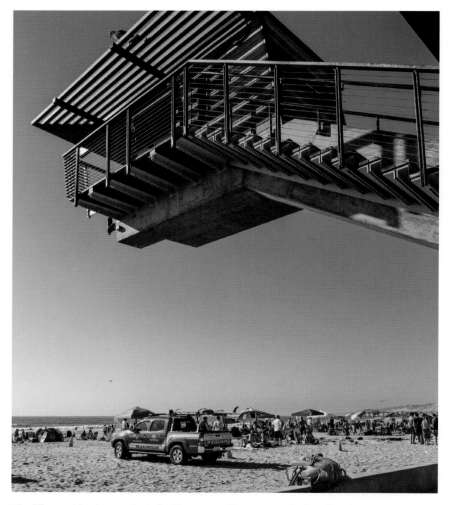

The lifeguard lookout at La Jolla Shores cantilevers over the beach as beachgoers enjoy cloudless California sunshine.

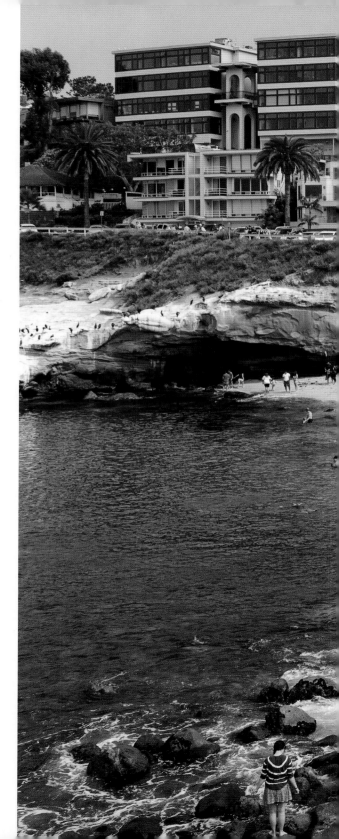

The ever-popular La Jolla Cove beach is shared by swimmers, sunbathers, and marine life.

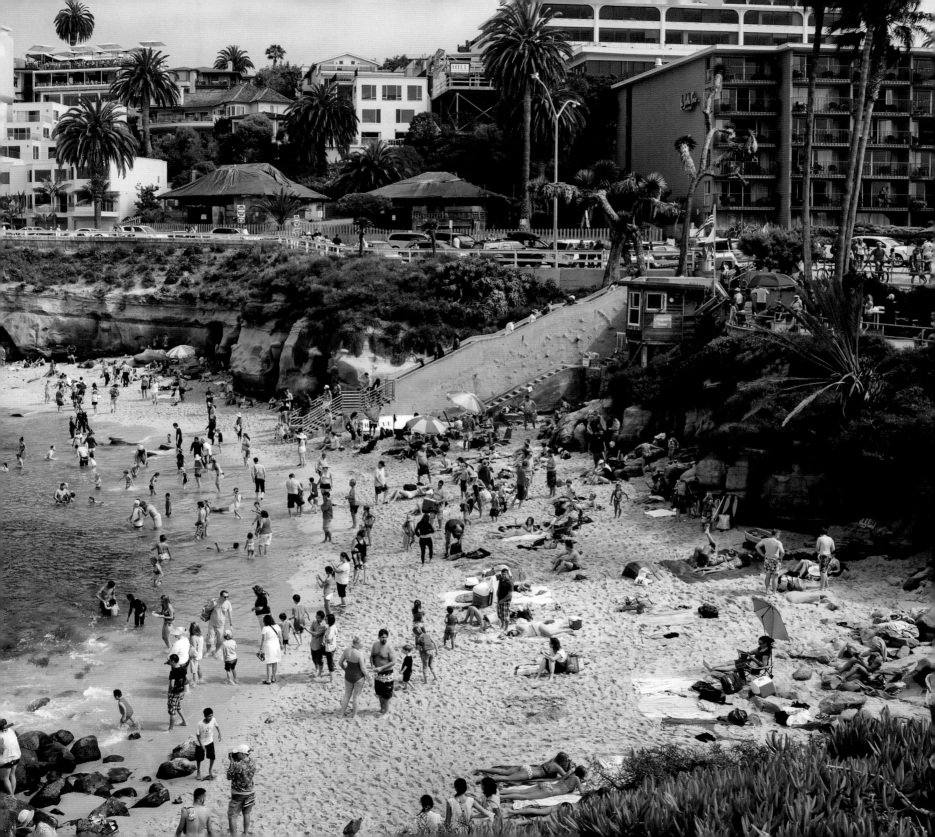

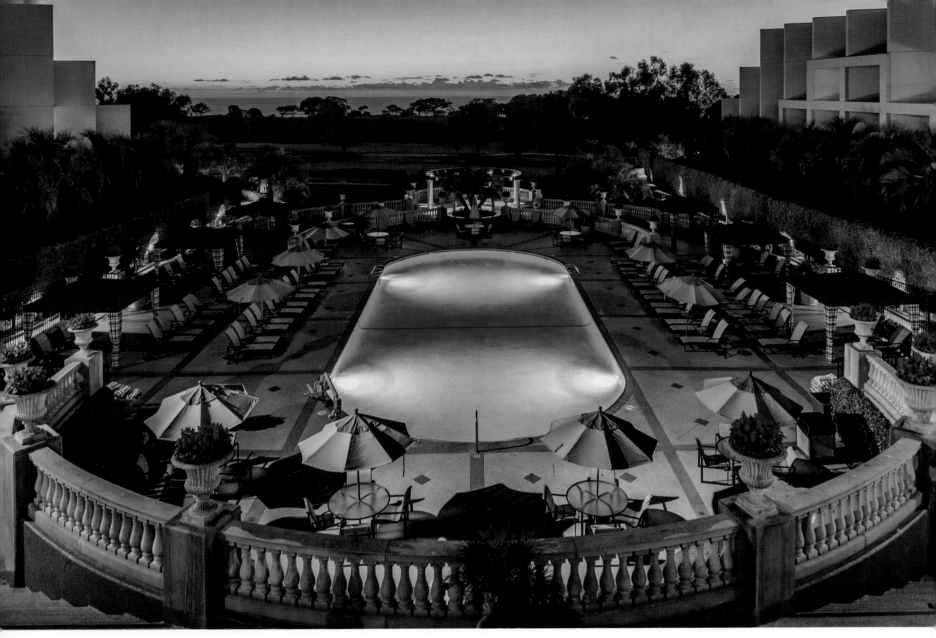

La Jolla is home to wonderful guest accommodations with exceptional views as pictured here. The Hilton La Jolla affords a view of the Torrey Pines Golf Course while the La Valencia Hotel overlooks La Jolla Cove.

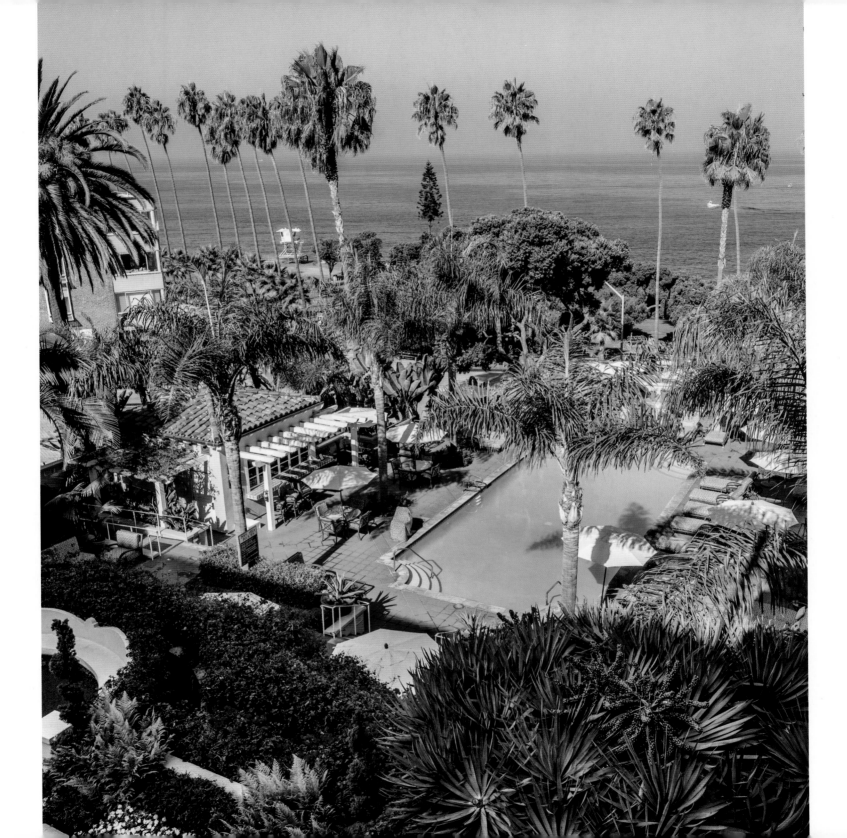

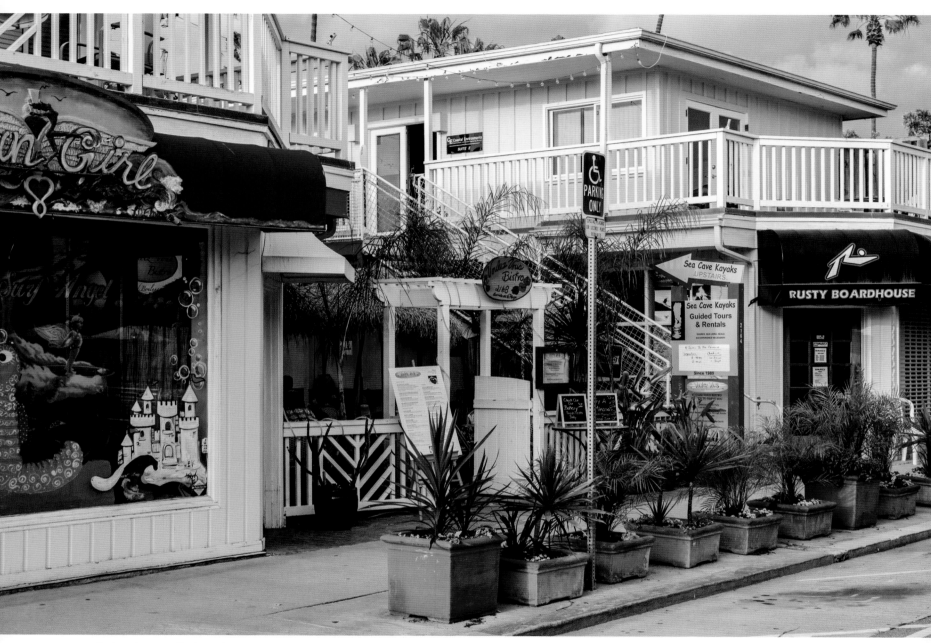

The beach town vibe is evident on Avenida de la Playa, La Jolla Shore's main drag.

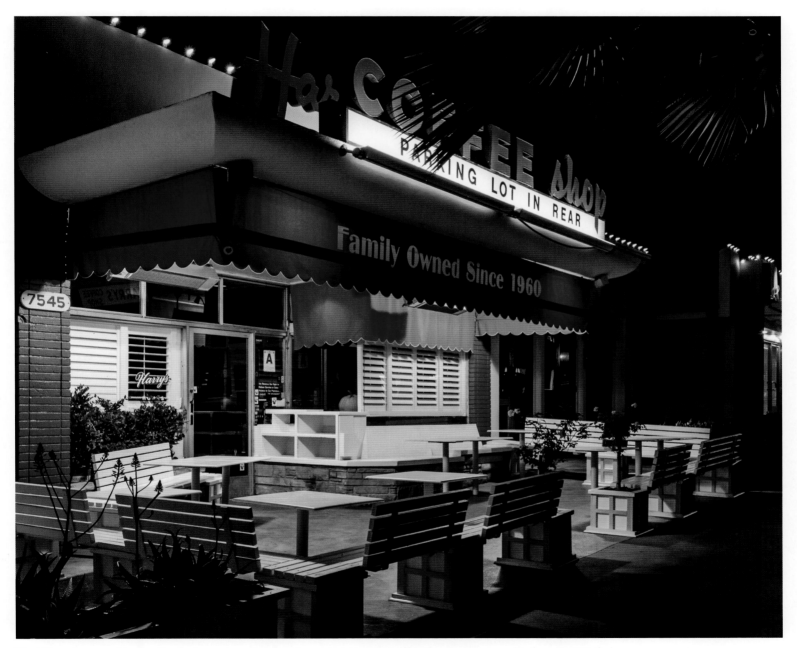

The Village has a multitude of exclusive and modern boutiques, but Harry's Coffee Shop has managed to keep its 60's feel.

A vivid textured wall points to the Pacific Ocean *(above)*, while a nautically-themed art installation shades the afternoon sun *(right)* at the La Jolla branch of the Museum of Contemporary Art San Diego.

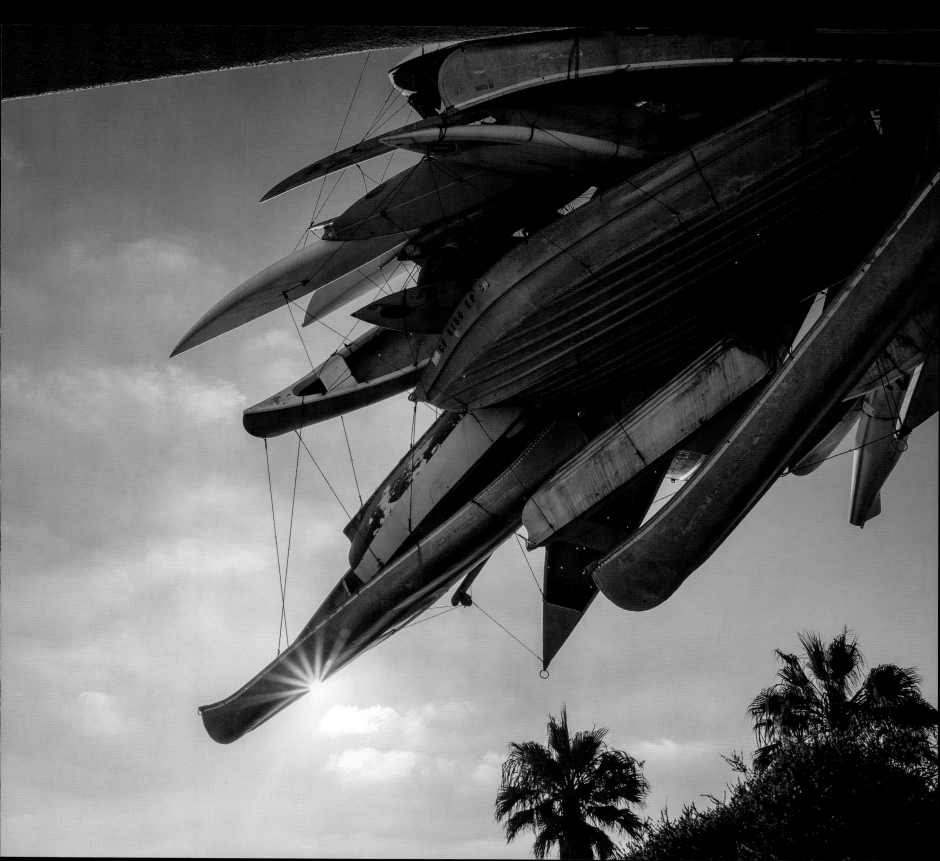

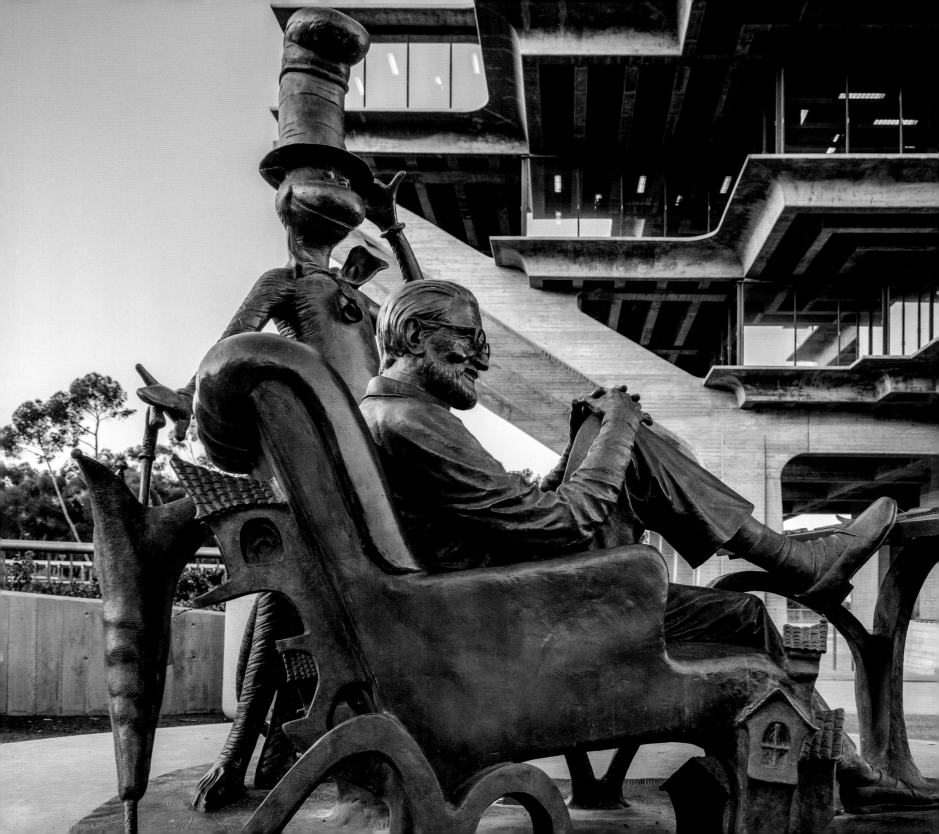

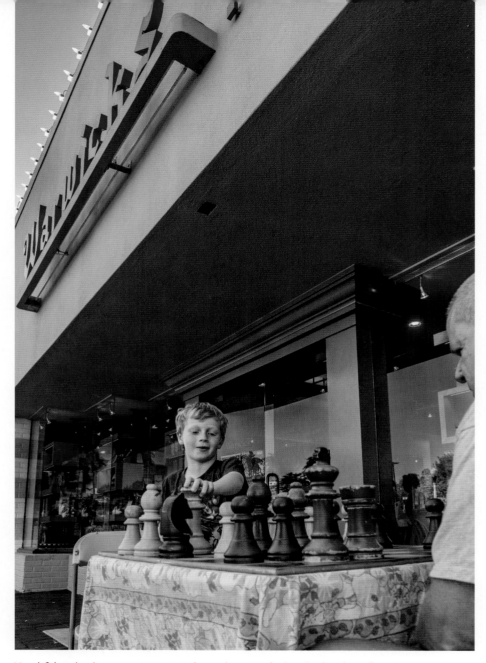

Youthful enthusiasm meets seasoned experience at the iconic chessboard
in front of Warwick's, a La Jolla institution for generations.

Dr. Seuss (aka Theodor Geisel) and the Cat in the Hat take a break in front of
the Geisel Library at the University of California, San Diego.

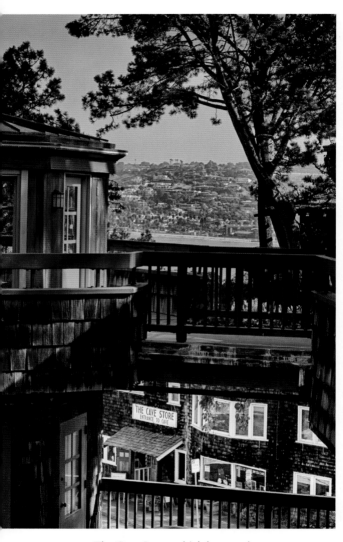

The Cave Store, which houses the entrance to the Sunny Jim Cave, peeks through an opening between the buildings on Coastal Walk.

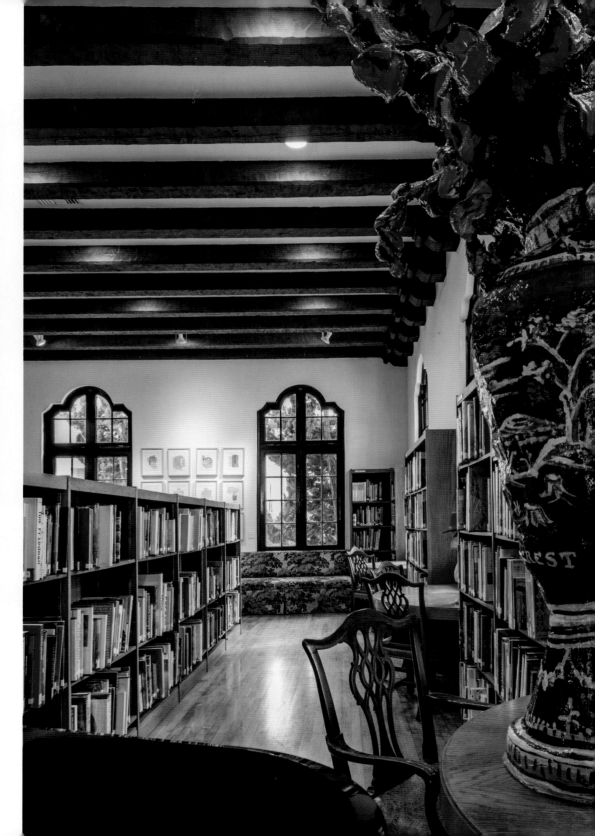

The Athenaeum Music & Arts Library is one of the charming buildings in the Village.

46

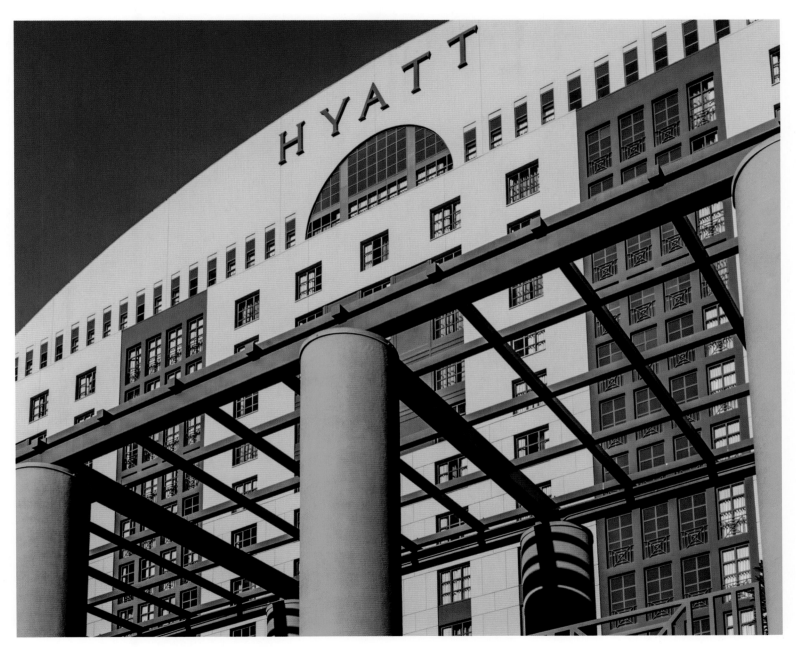

The La Jolla Hyatt Hotel exhibits a postmodern facade.

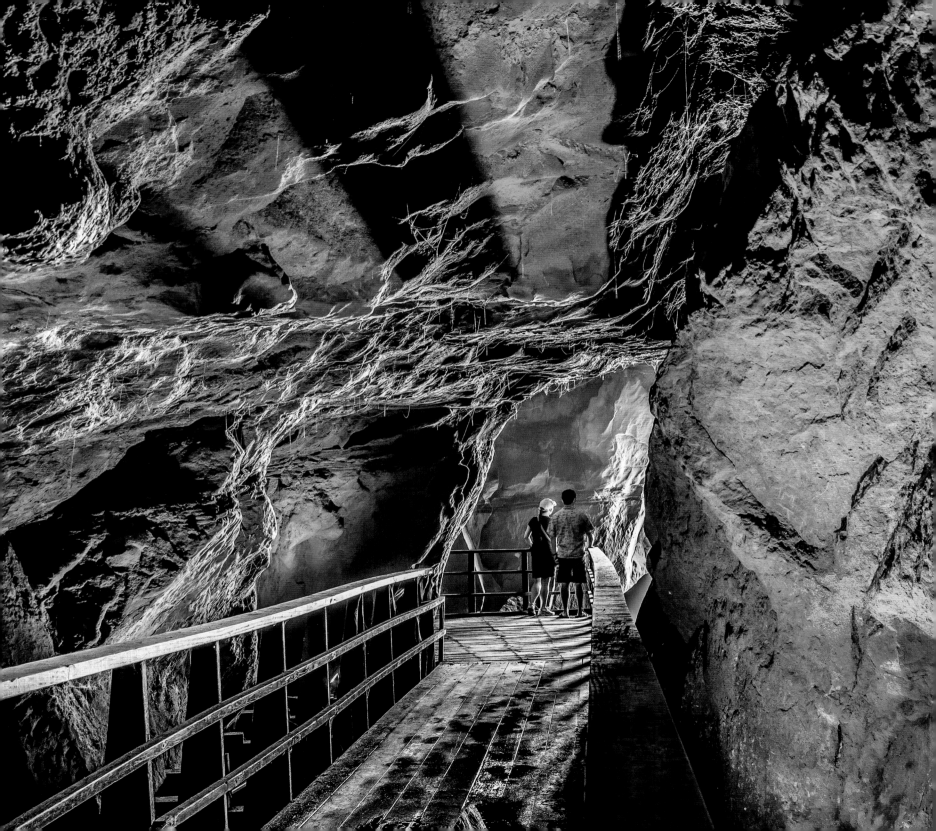

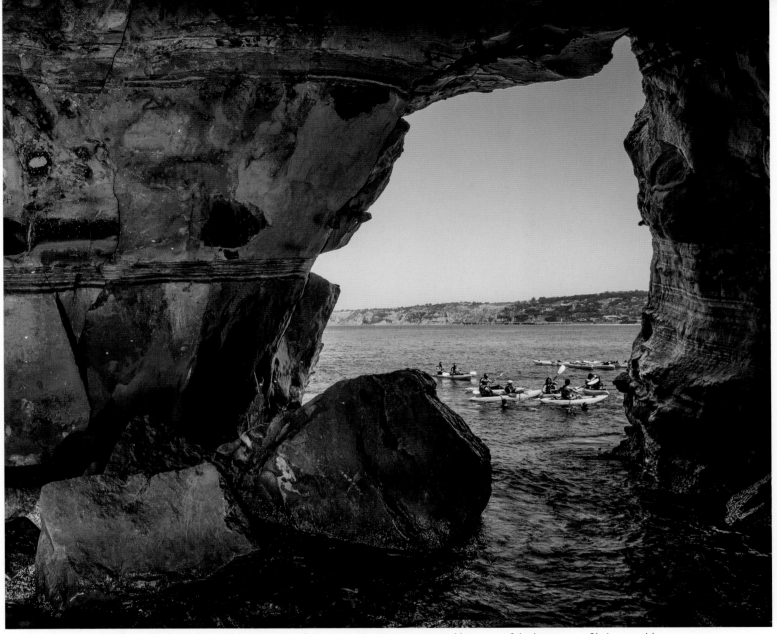

Paddlers from La Jolla Shores linger in front of the opening of the Sunny Jim Cave, so named because of the human profile it resembles.

Two visitors arrive at the opening of the Sunny Jim Cave from the Cave Store
after descending the staircase in the man-made tunnel.

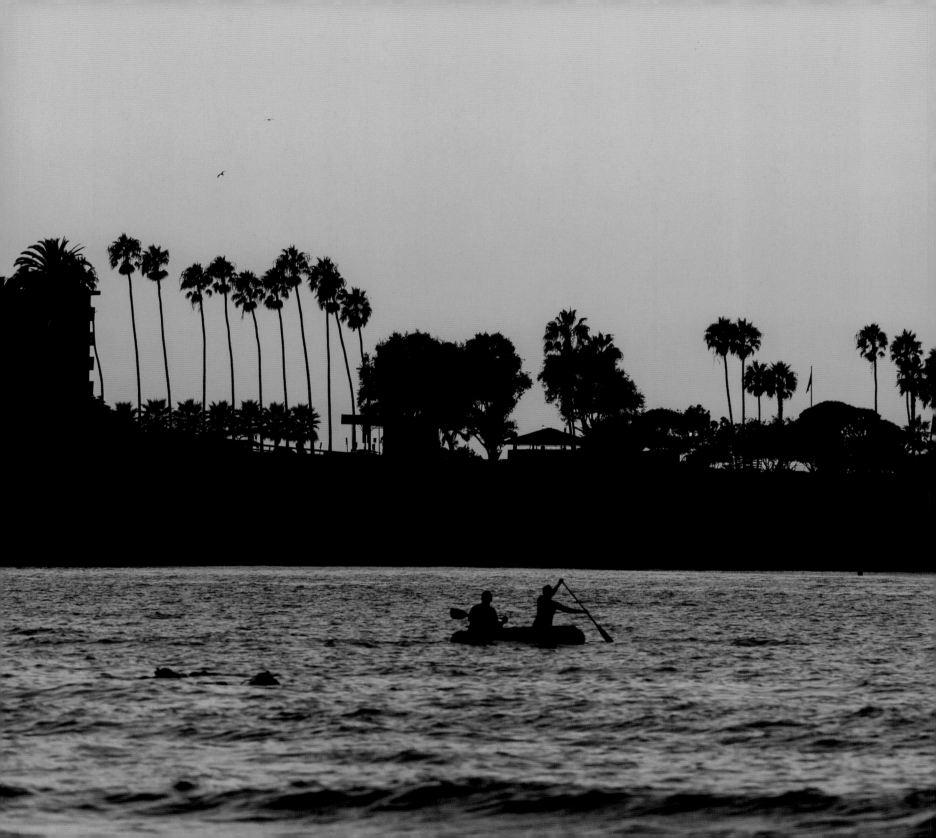

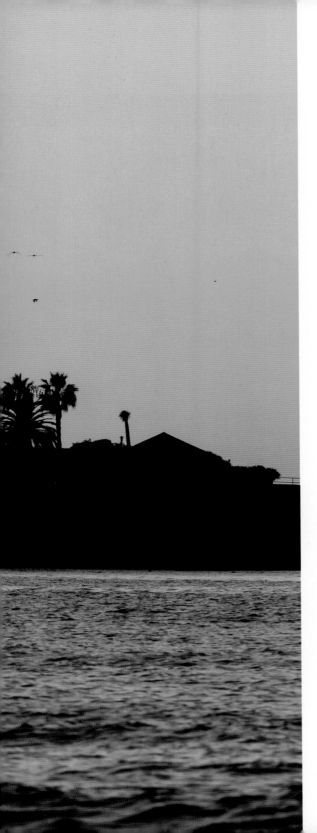

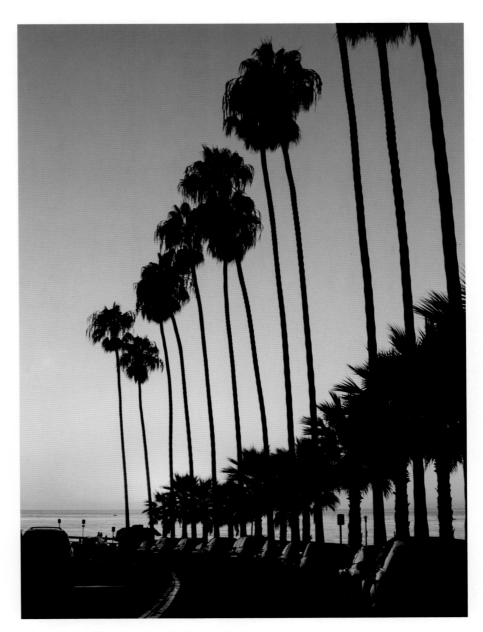

Palm trees line Ellen Browning Scripps Park.

Kayakers paddle to shore with the Cove behind them
silhouetted against the warm evening sky.

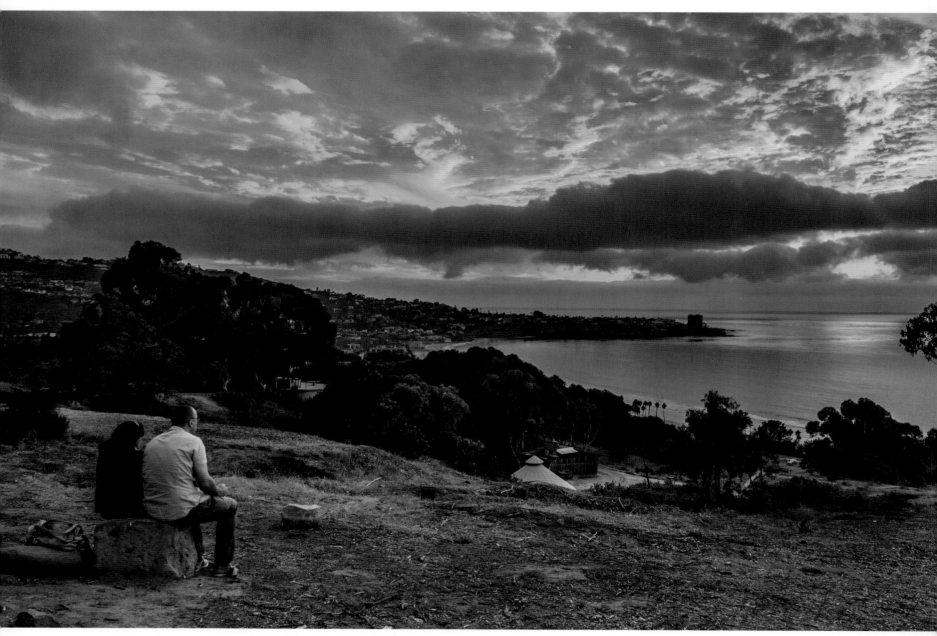

A couple enjoys the sunset from a clearing overlooking the Scripps Institute of Oceanography.

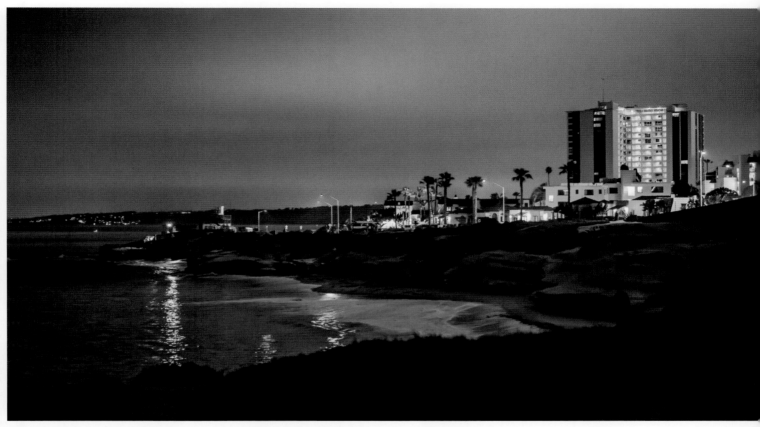

A light evening mist causes the Village lights to illuminate the night sky with a purple glow.

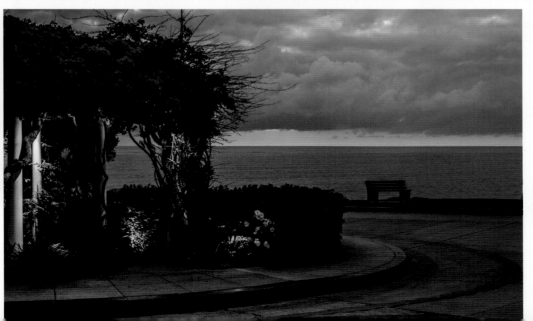

A peaceful evening calm envelopes Coast Boulevard Park.

53

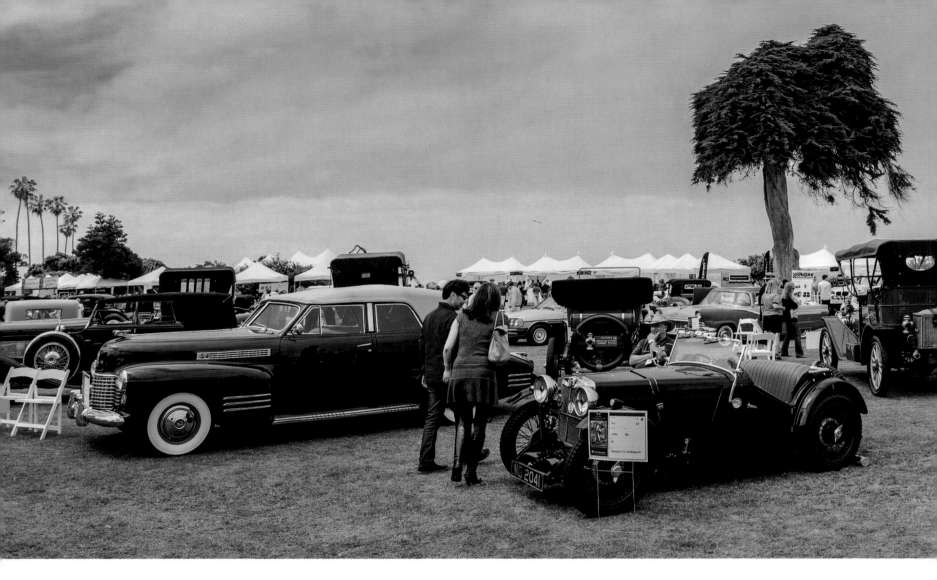

Each year proud owners and envious droolers gather in a celebration of the art of the automobile at the La Jolla Concours d'Elegance in Ellen Browning Scripps Park.

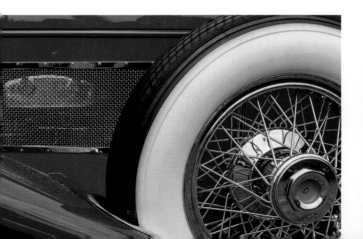
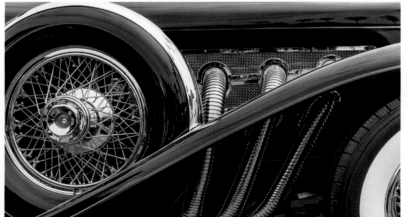

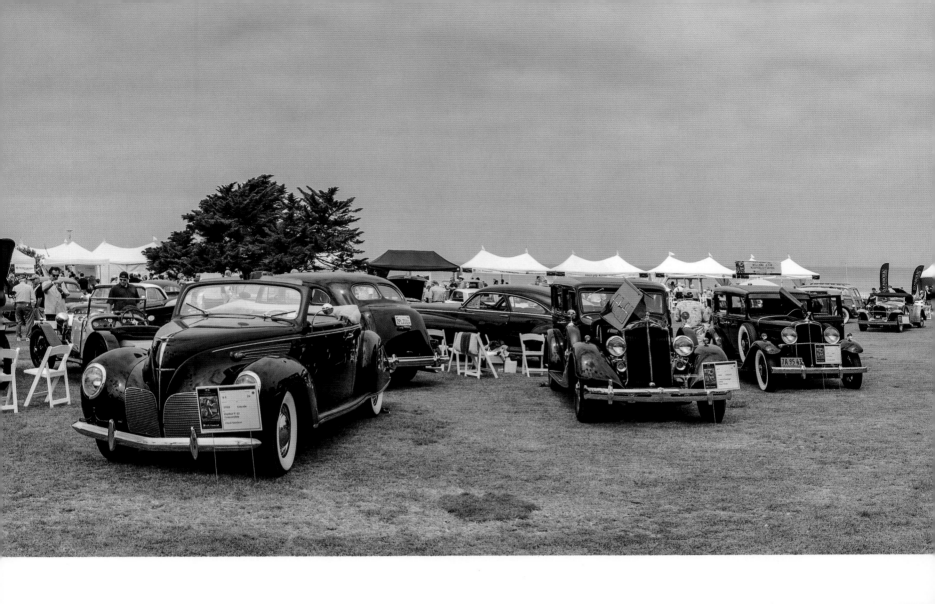
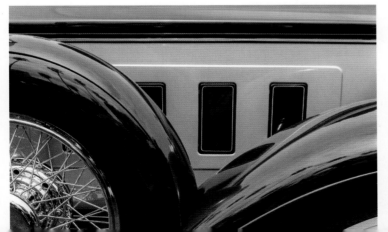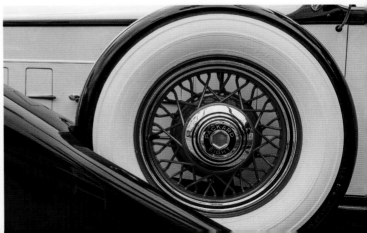

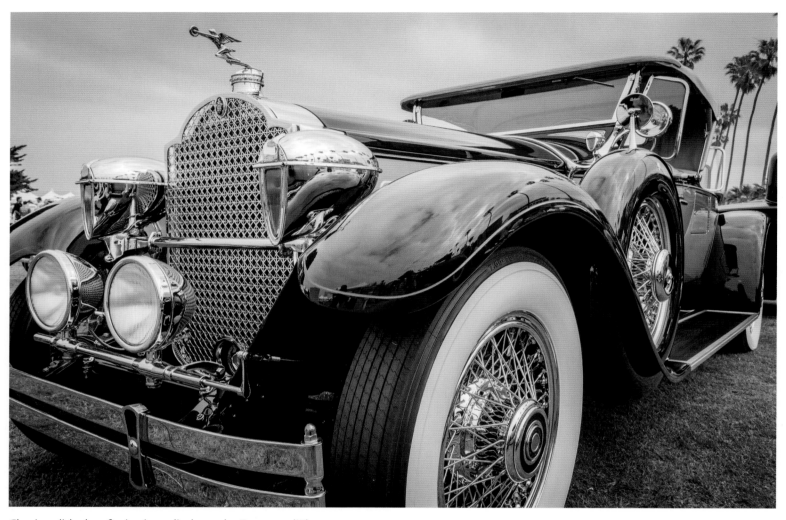

Classic polished perfection is on display at the Concours d'Elegance.

Epitomizing La Jolla's upscale character is this view from one
Italian luxury car dealership to another.

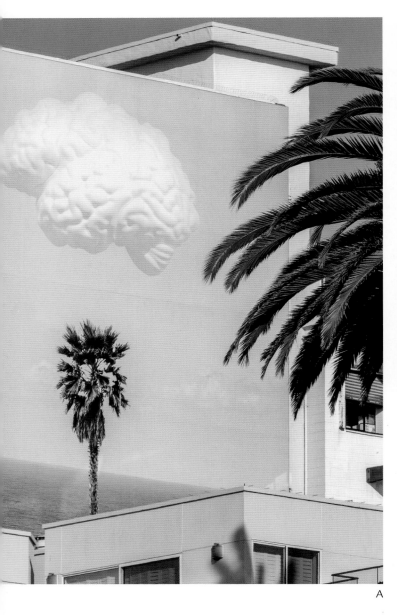

A

B

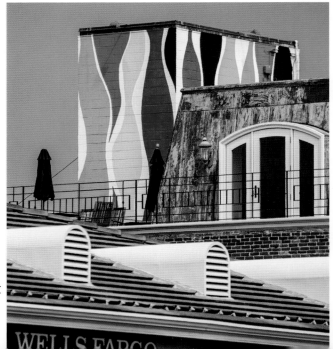

C

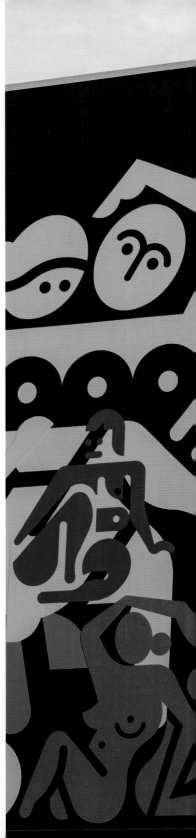

58

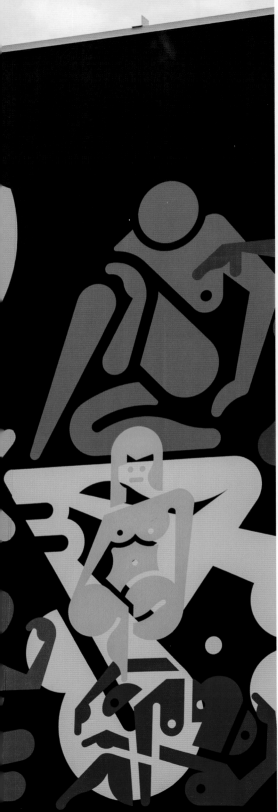

D

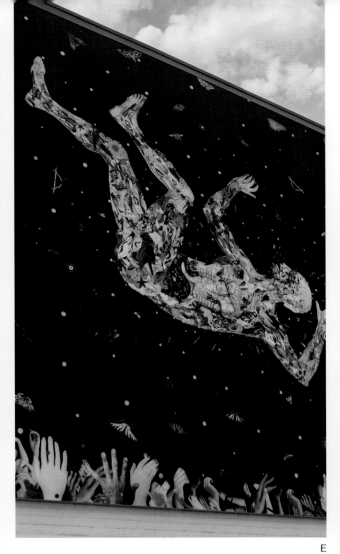

F

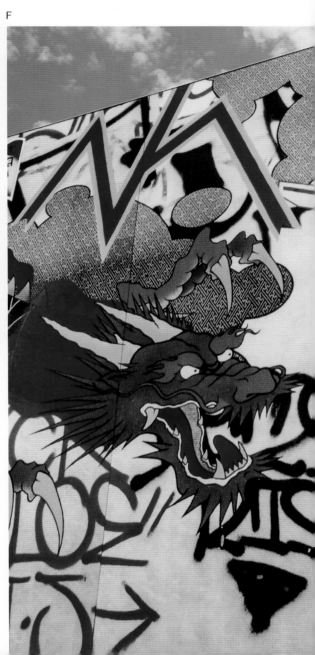

E

Since its founding, La Jolla has been a haven for artists and the arts. That legacy continues thanks to its many art galleries and public art installations. These are six of the many vivid murals decorating public spaces in the Village:

A. John Baldessari, *Brain/Cloud*
B. Roy McMakin, *Favorite Color*
C. Kim MacConnel, *Girl from Ipanema*
D. Ryan McGinness, *53 Women*
E. Fred Tomaselli, *Expecting to Fly (for the Zeros)*
F. Gajin Fujita, *Tail Whip*

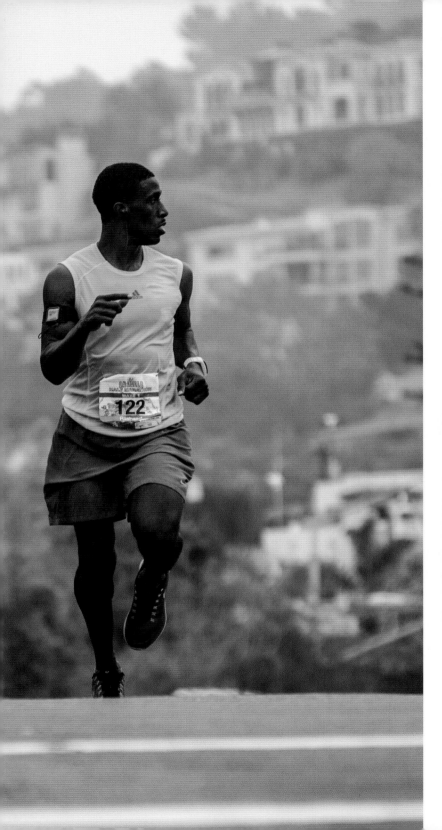
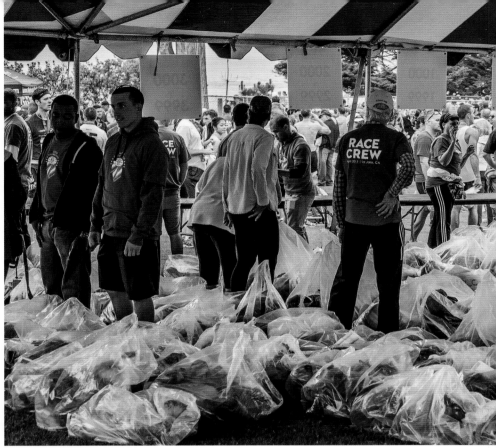
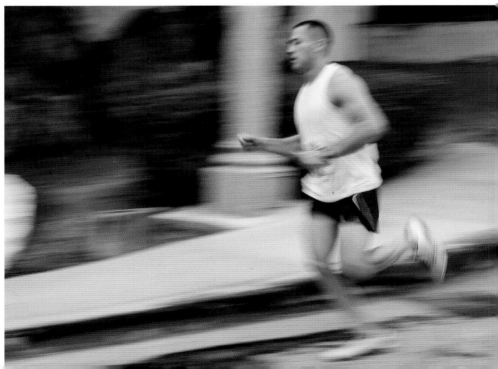

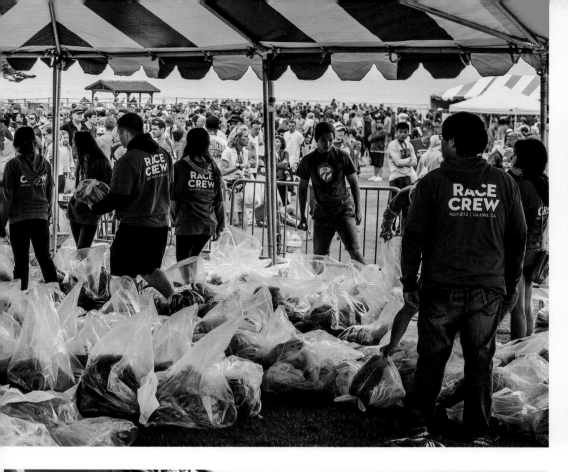

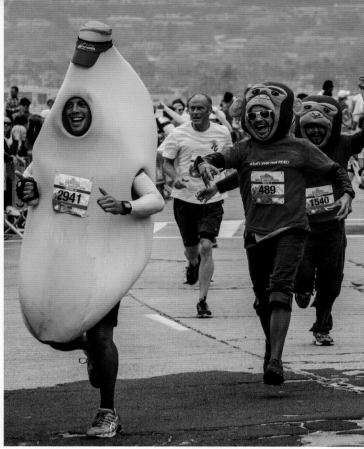

Serious runners and those out for some fun participate in the annual La Jolla Half Marathon.

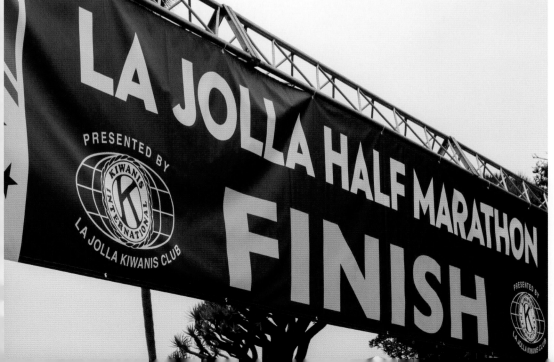

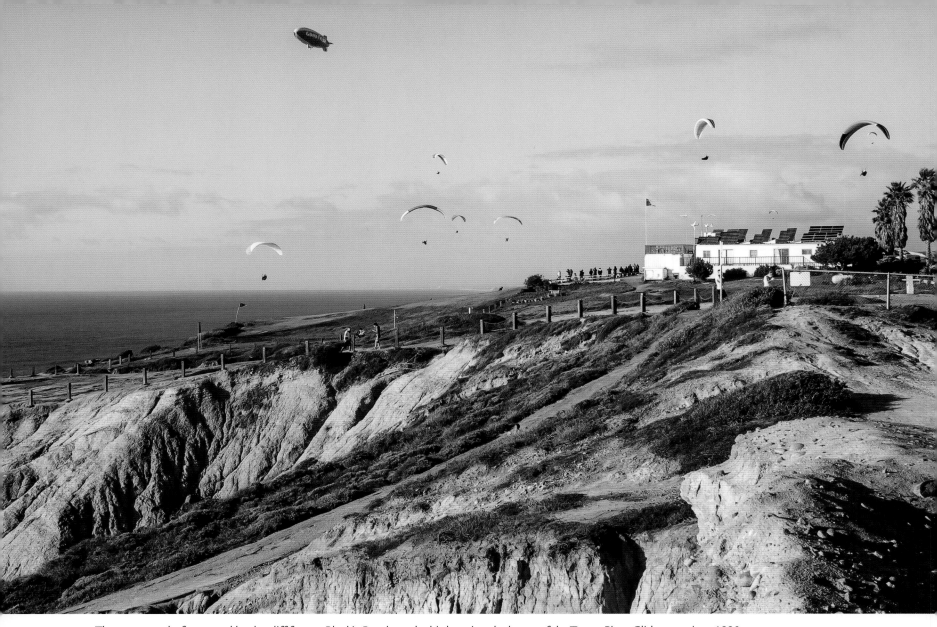

The strong updrafts created by the cliff face at Black's Beach made this location the home of the Torrey Pines Gliderport since 1930.

A paraglider takes in the view looking down the Torrey Pines cliffs to Black's Beach.

Following pages: A distant ship passes through sunset's afterglow on its way out to sea.

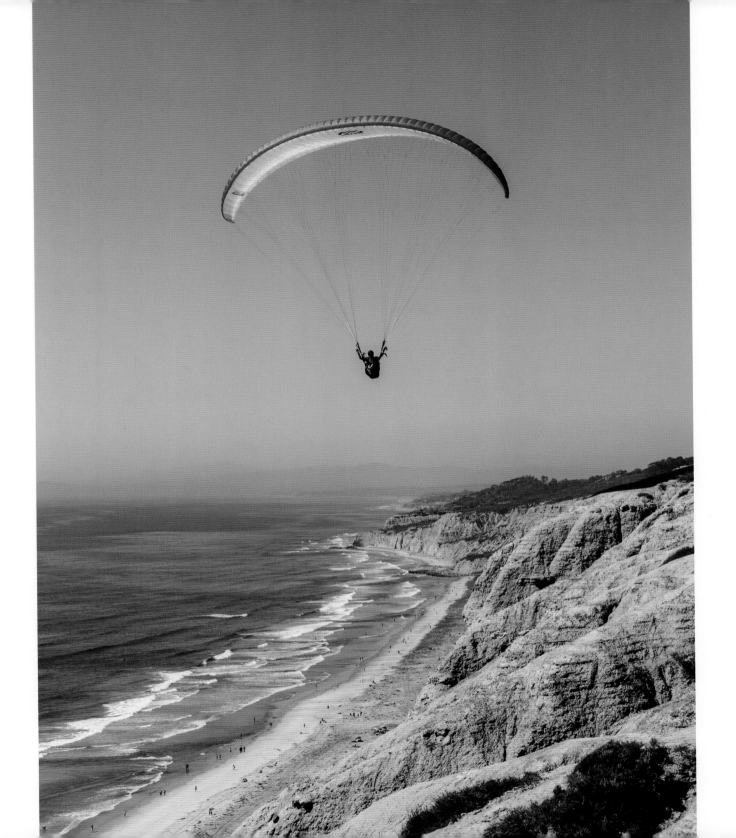

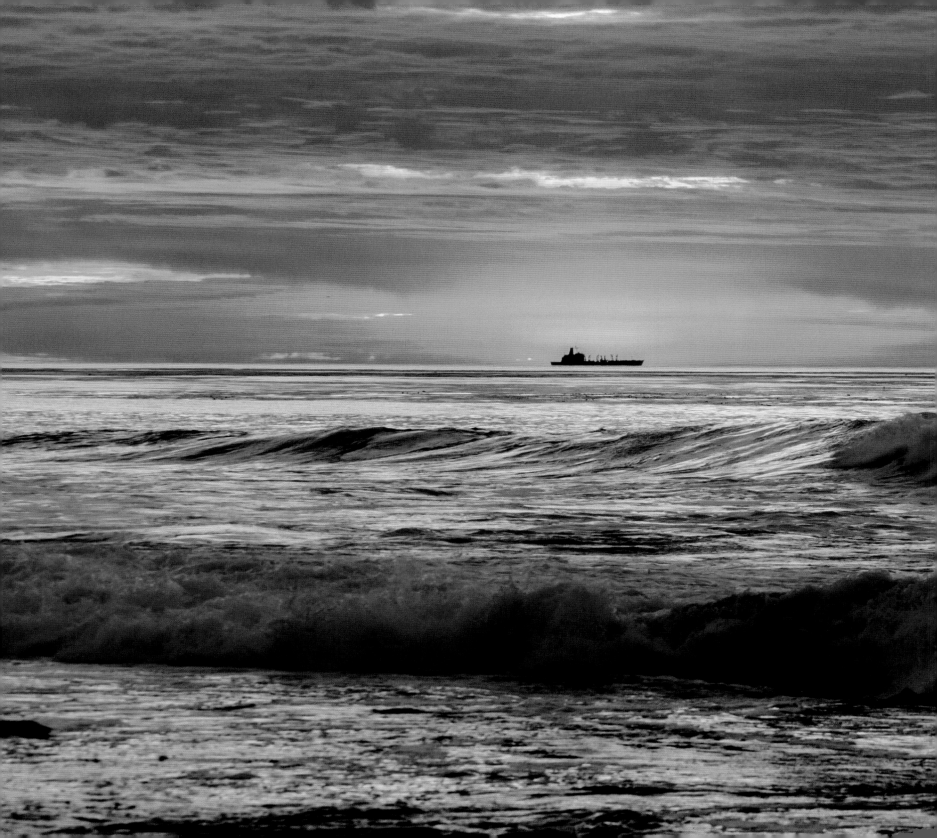

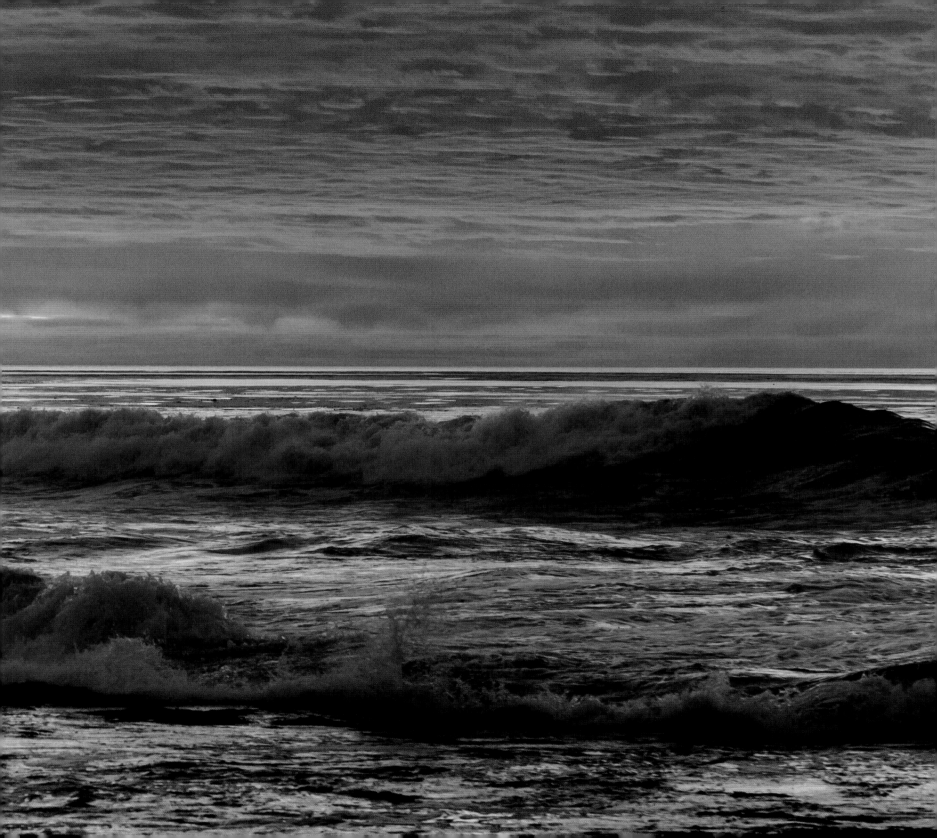

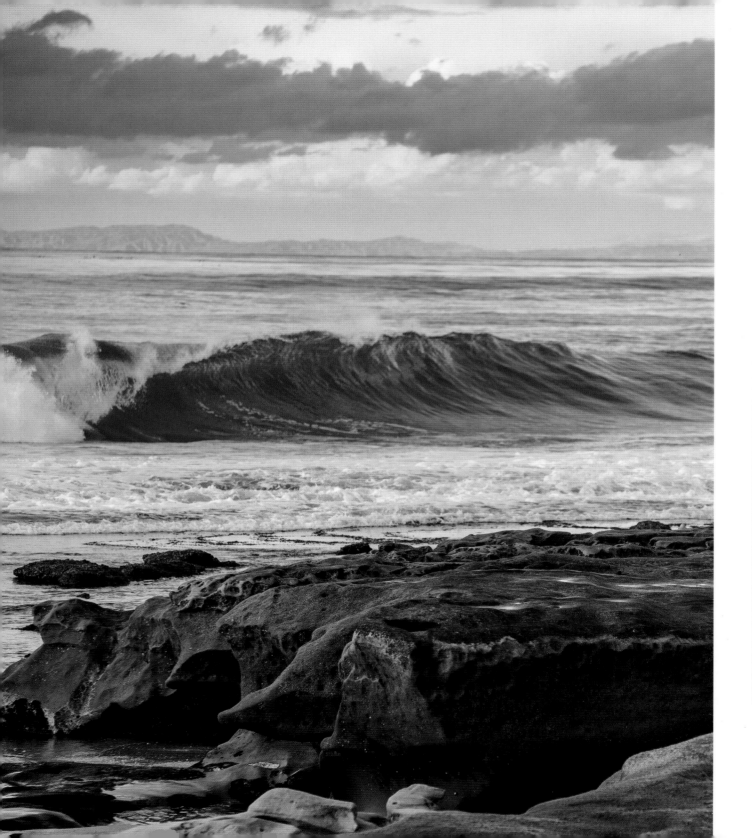

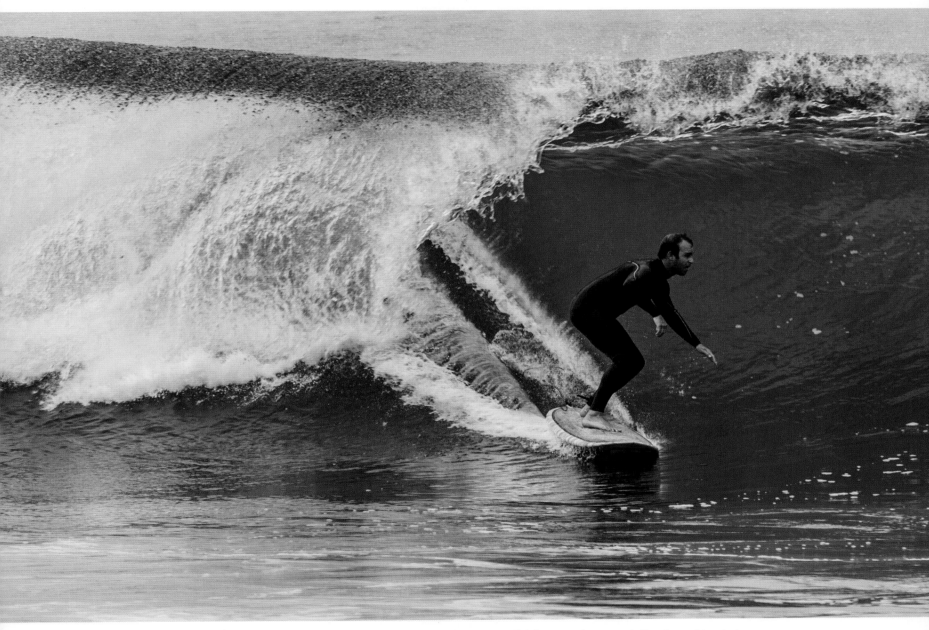

The beaches of La Jolla offer waves to surfers of varying skill levels from the gentle at La Jolla Shores to the more challenging at Hospitals, Windansea, and Black's and to the body-surfing only at Boomers. Here a surfer catches a wave near Nicholson Point.

Following pages: A late evening glow descends over Hospitals Beach.

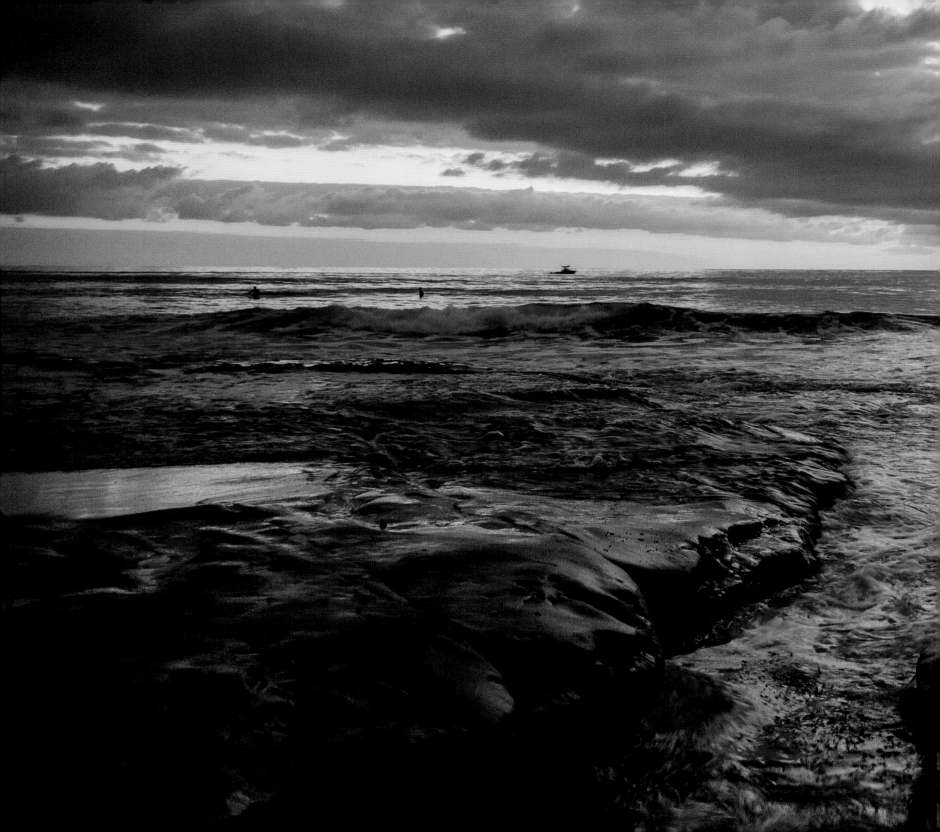

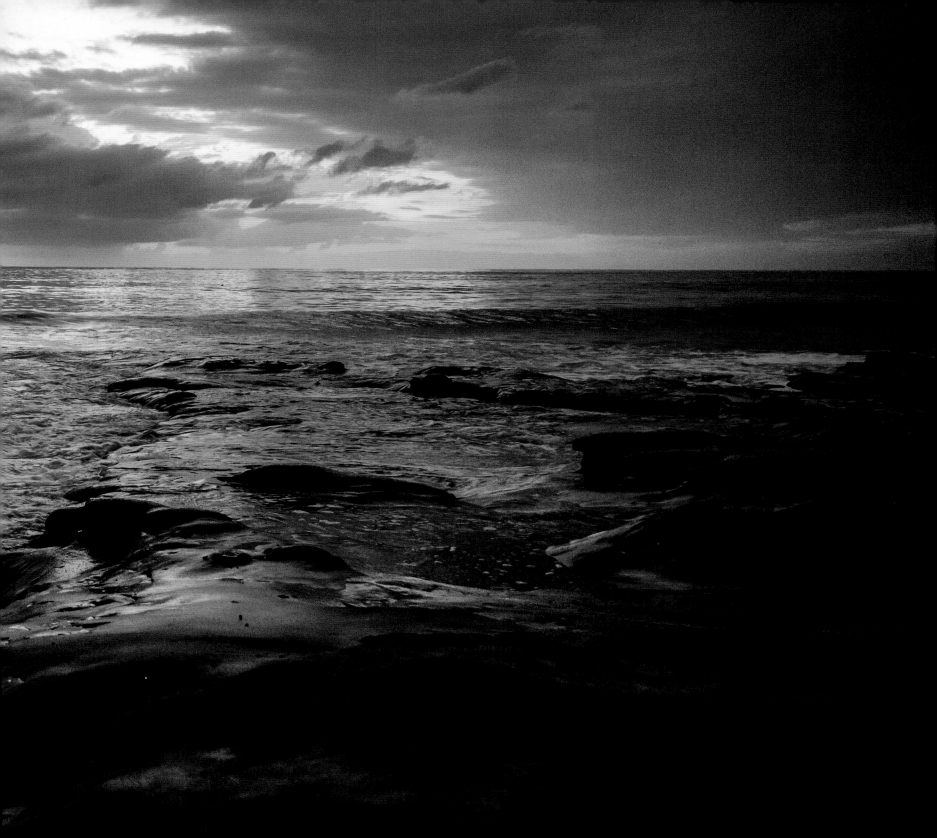

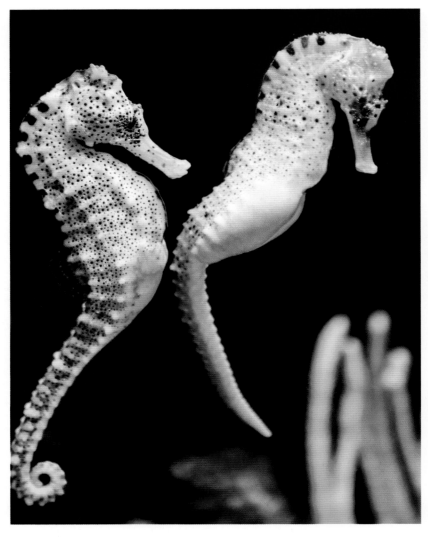

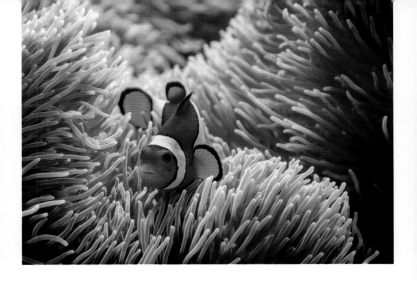

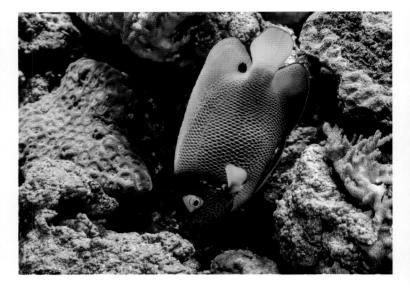

Spectacular sea creatures are on display at the Birch Aquarium
at Scripps Institution of Oceanography/UCSD.

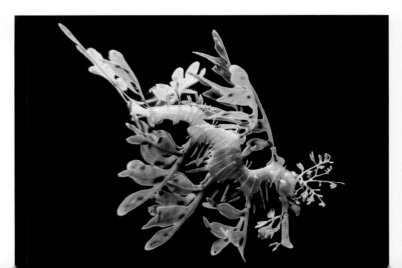

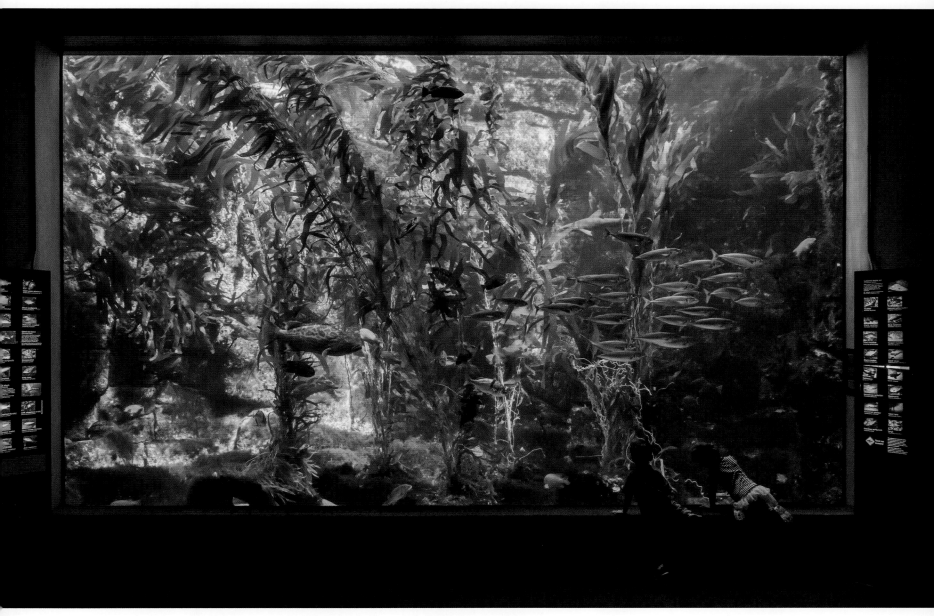

Two budding oceanographers are mesmerized by the majestic Kelp Forest Tank at the aquarium.

Following pages: Walkers enjoy the mist-shrouded views of the massive Torrey Pines cliffs.

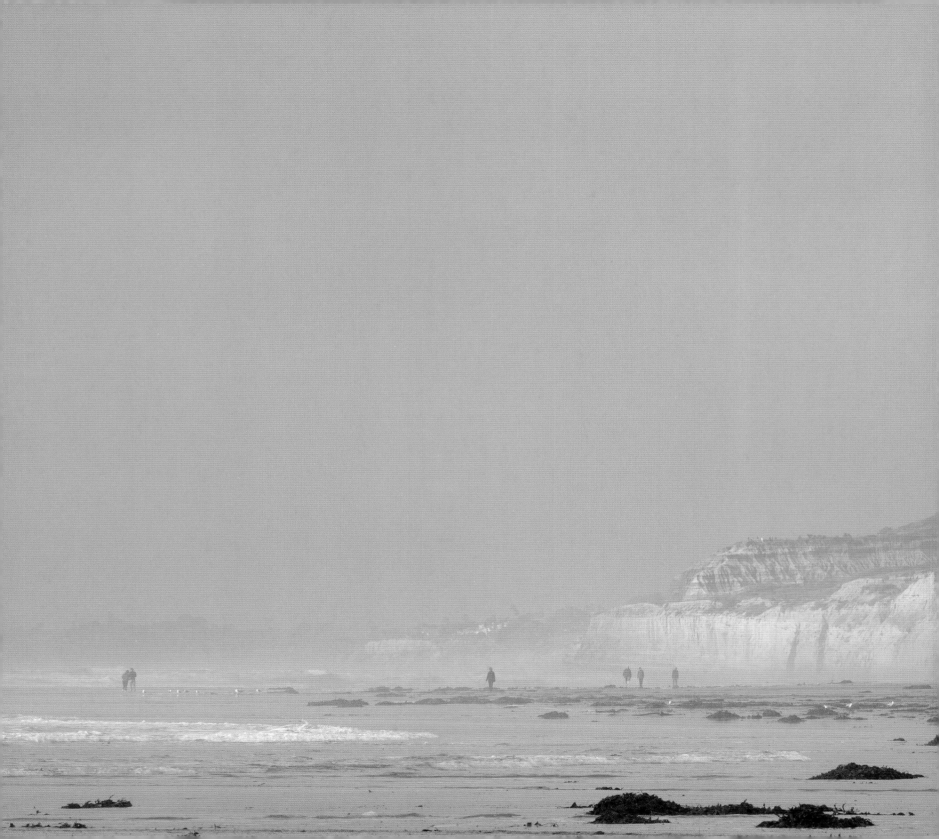

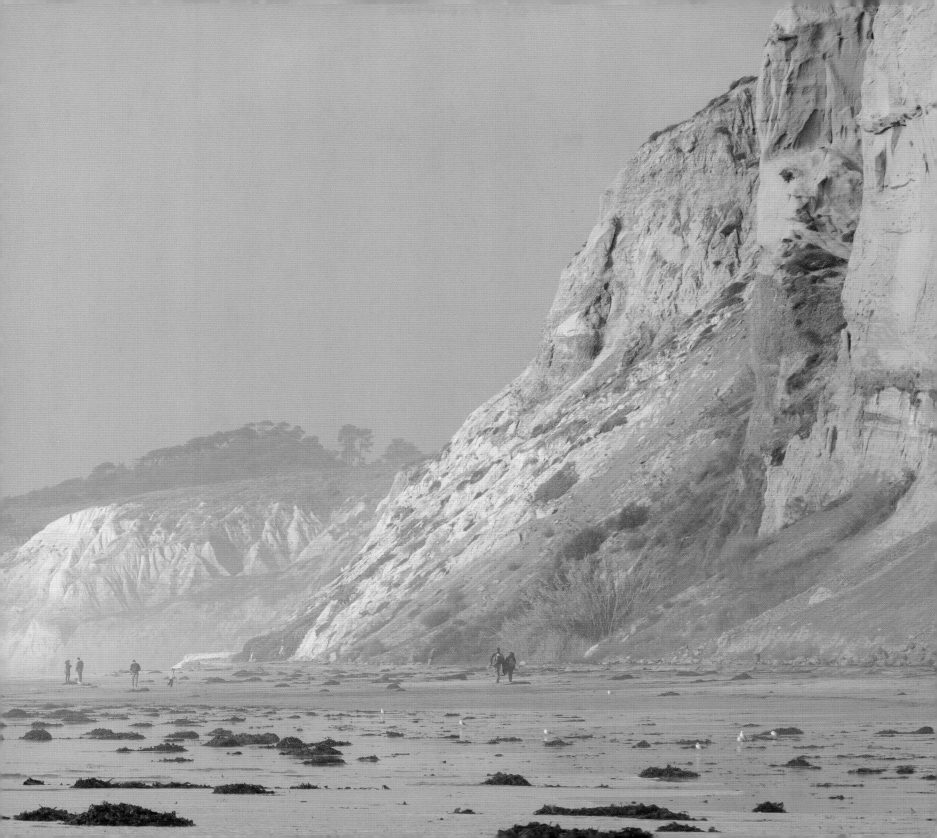

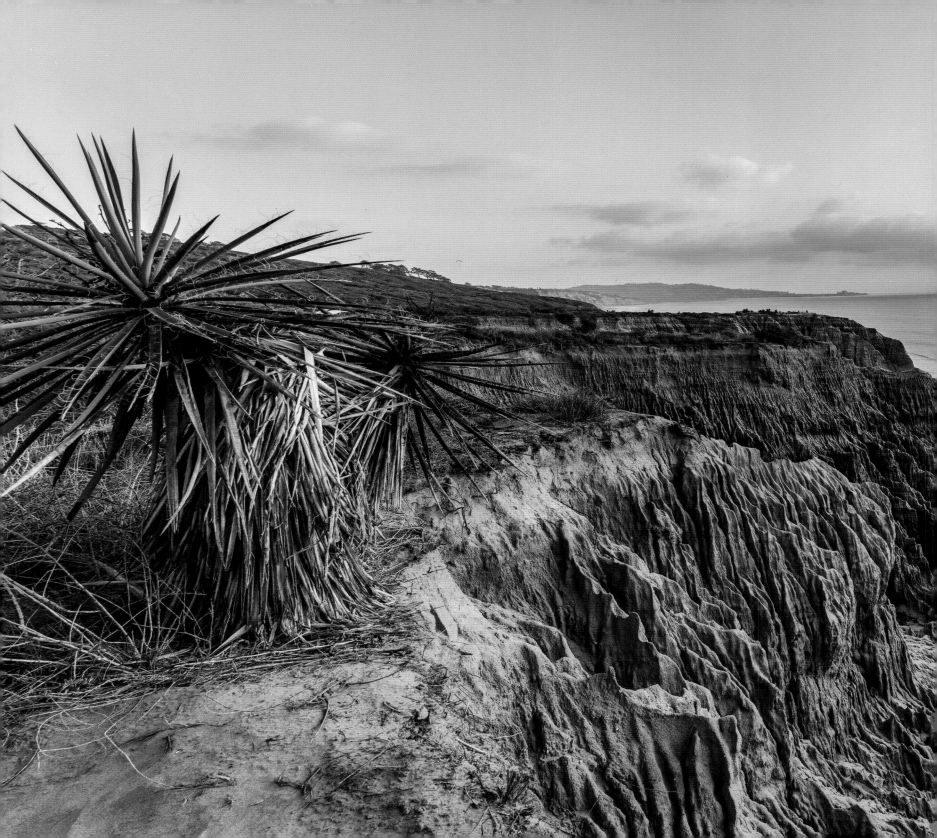

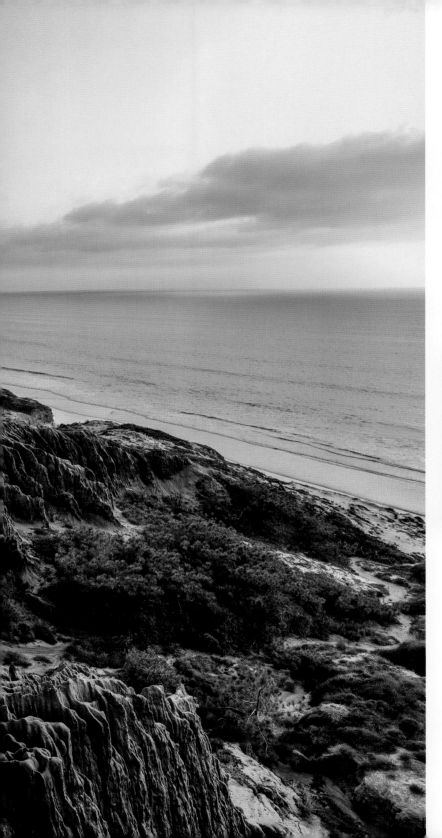

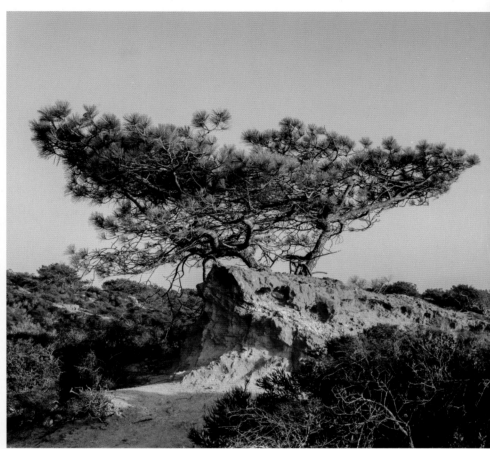

A Torrey pine stands proudly in the nature reserve that bears its name.

The afternoon sun casts dramatic shadows across the weathered cliff face of the Big Basin in the Torrey Pines State Natural Reserve.

La Jolla's mild climate is perfect for many plants. Colorful flowers are everywhere one turns.

A heavily patinaed bench adds its rustic charm to the Village.

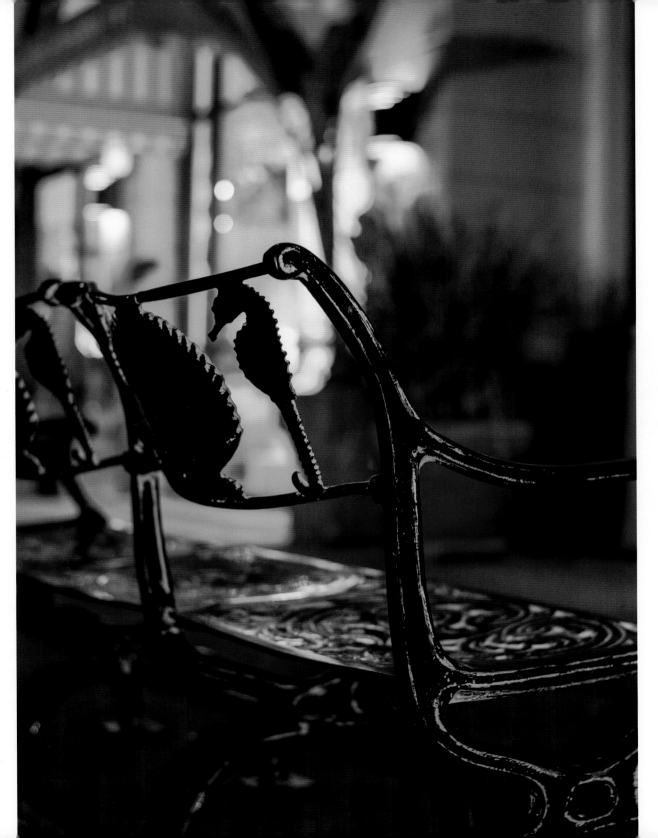

The ocean has always been a key to La Jolla's appeal and is celebrated here with a sea-themed bench on one of the Village's shopping streets.

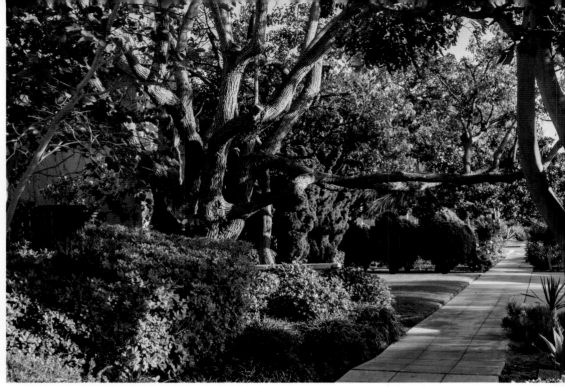

A serene and welcoming tree-shaded sidewalk in the Village, where flowering plants are found in neighborhood gardens.

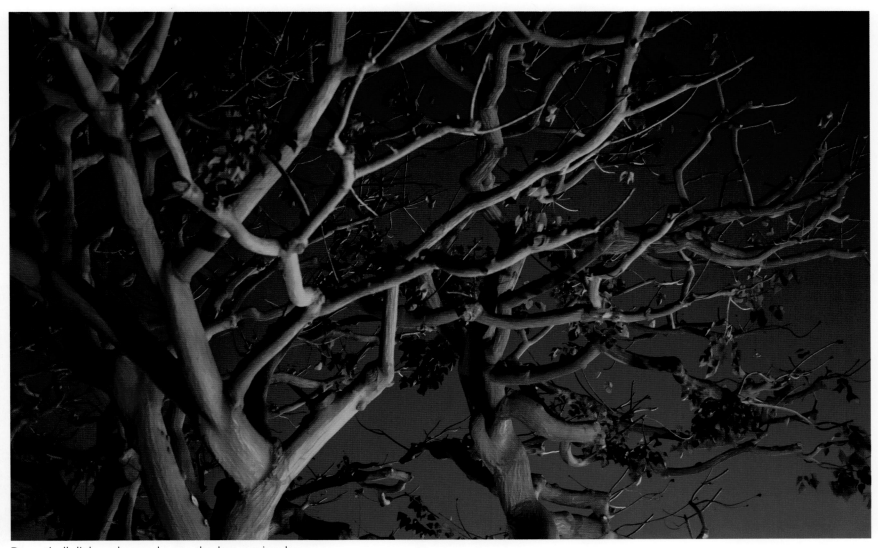

Dramatically lit branches reach up to the deep evening sky.

Street performers at one of the many Haute La Jolla Nights in the Village.

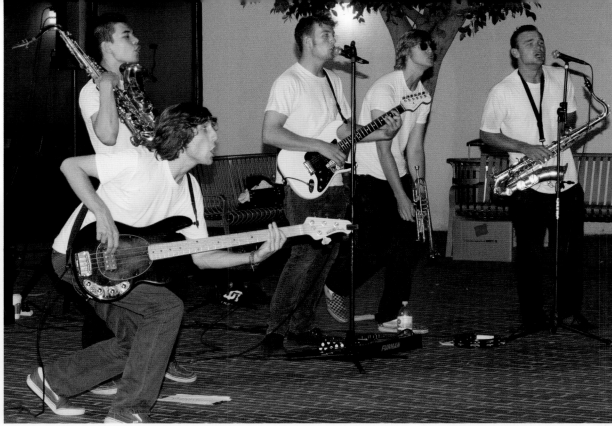

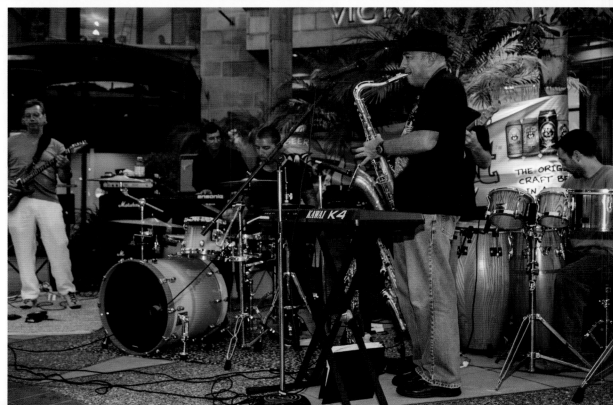

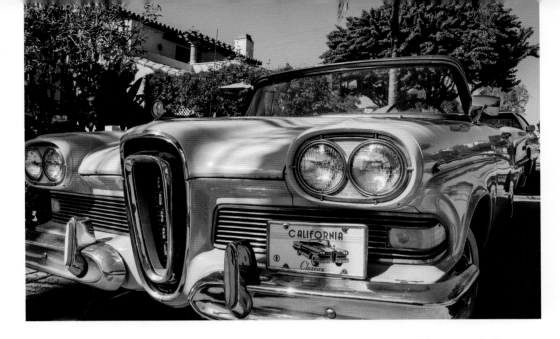

A pink 1958 Edsel basks in the sun.

A junior paint crew applies the finishing touches to a vehicle at the La Jolla Art and Wine Festival.

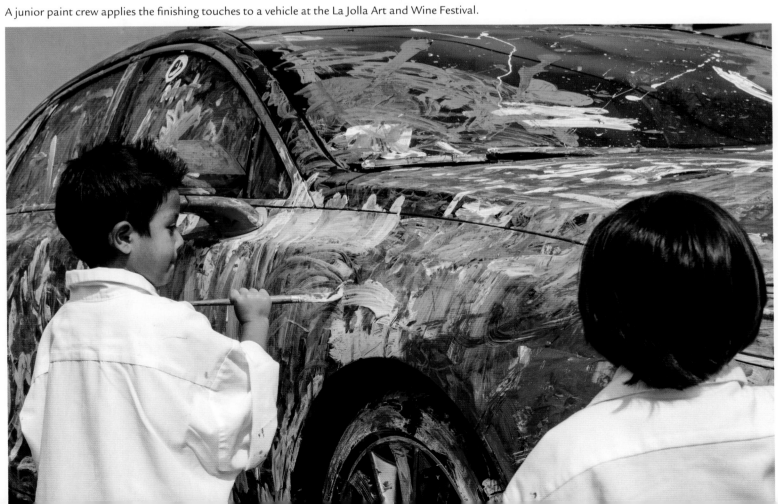

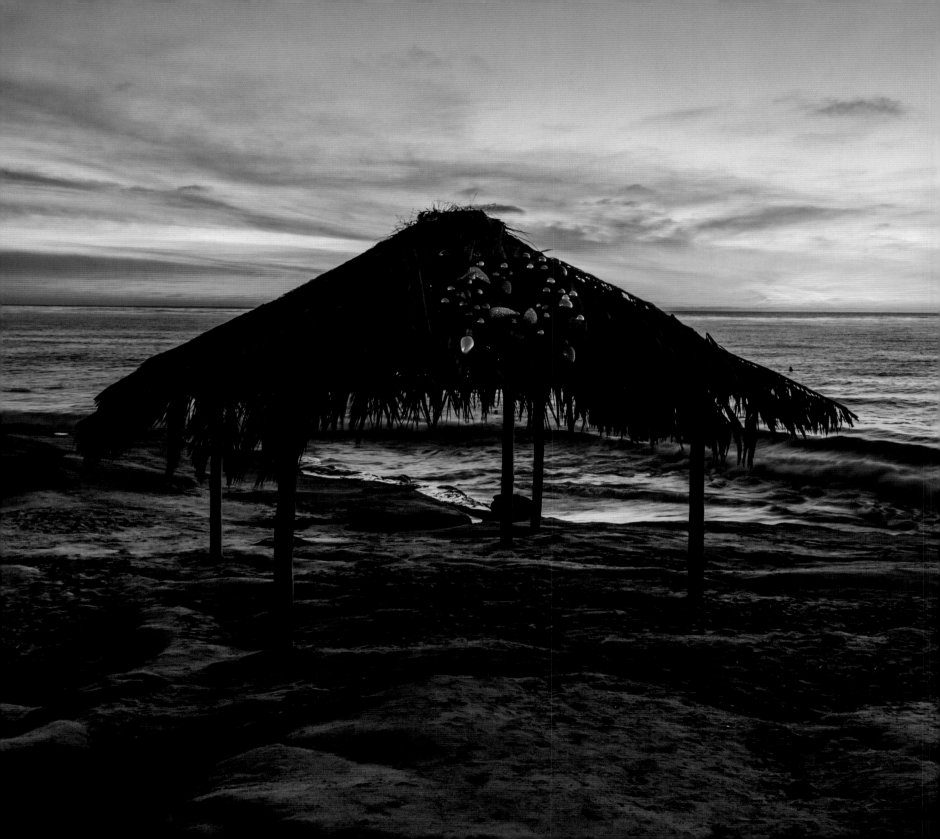

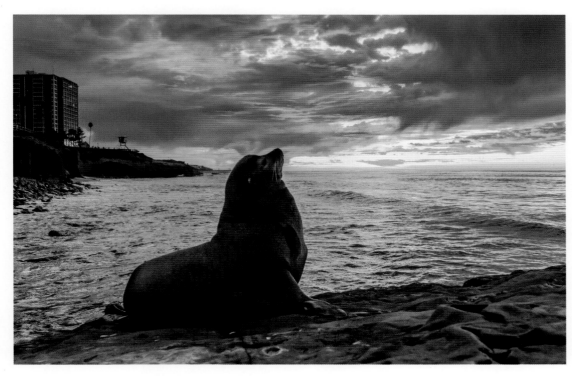

A sea lion strikes a proud pose before a dramatic evening sky.

The iconic Surf Shack on Windansea Beach was built by returning
WW II servicemen and has been in use ever since. Here it has been
decorated for the holiday season.

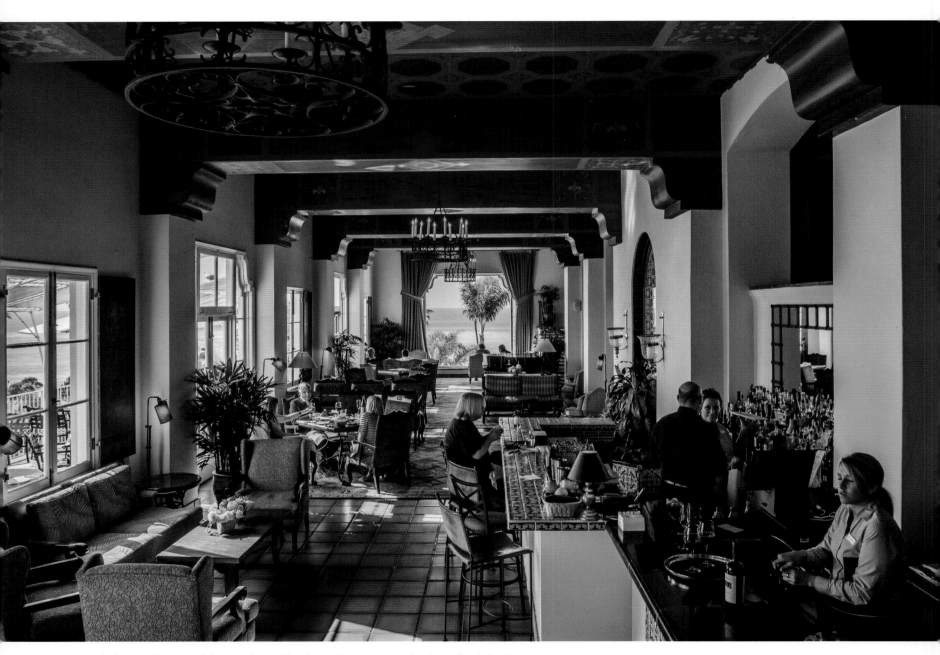

The bar and lounge of the La Valencia Hotel provides a spectacular view of La Jolla Cove.

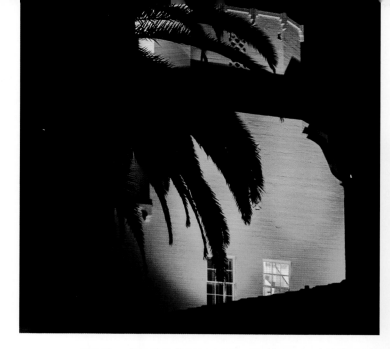

The pink tower of the La Valencia Hotel
has been a distinctive landmark since 1926.

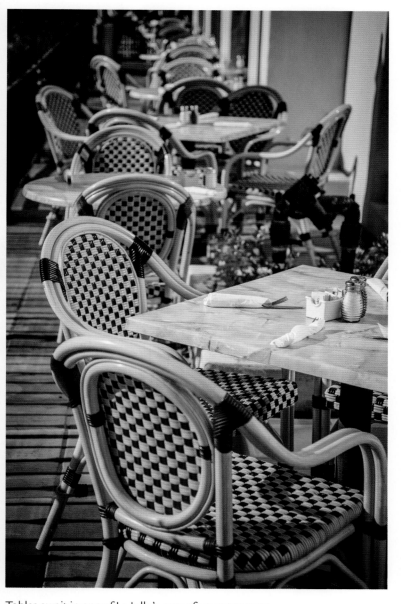

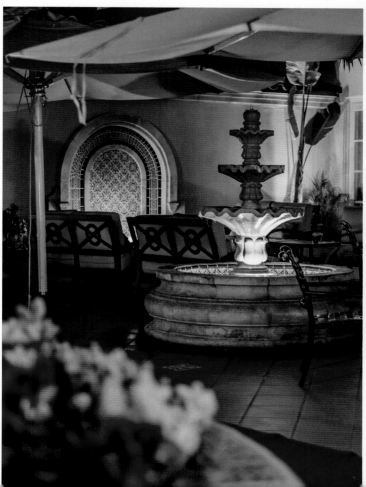

Tables await in one of La Jolla's many fine restaurants.

Understated evening elegance is part of the La Valencia Hotel. 87

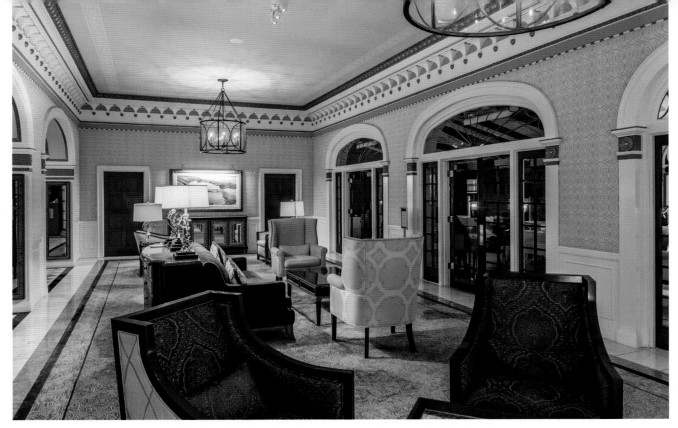

Refined sophistication is evident in the lobby of The Grande Colonial Hotel, La Jolla's oldest hotel.

The expansive grounds of the La Jolla Beach and Tennis Club provide a relaxed setting.

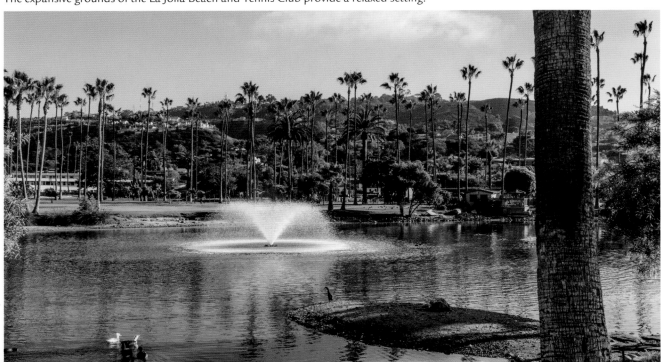

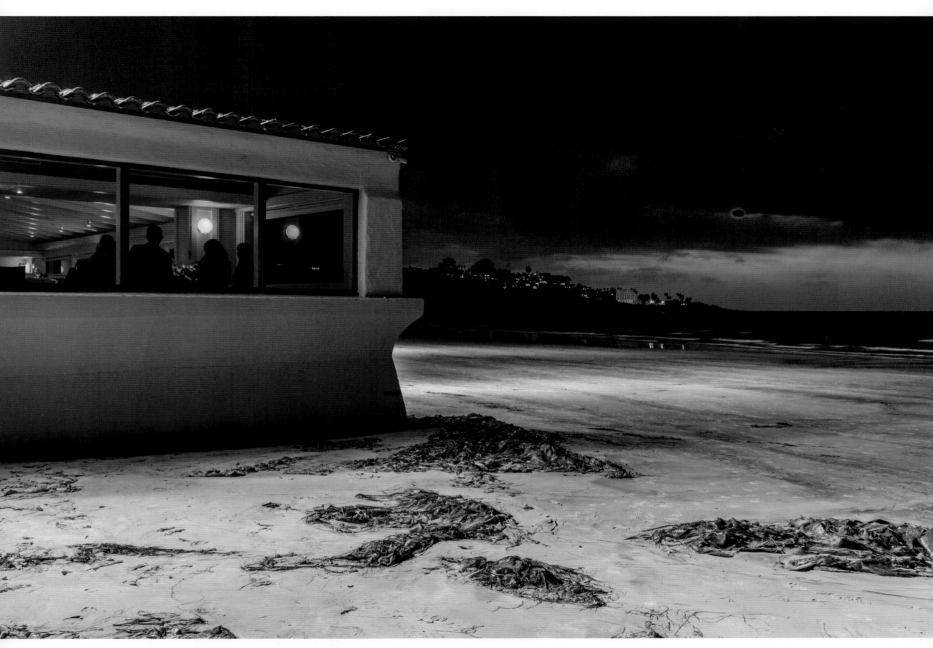

Diners enjoy the sunset from the beachfront Marine Room Restaurant at La Jolla Shores.

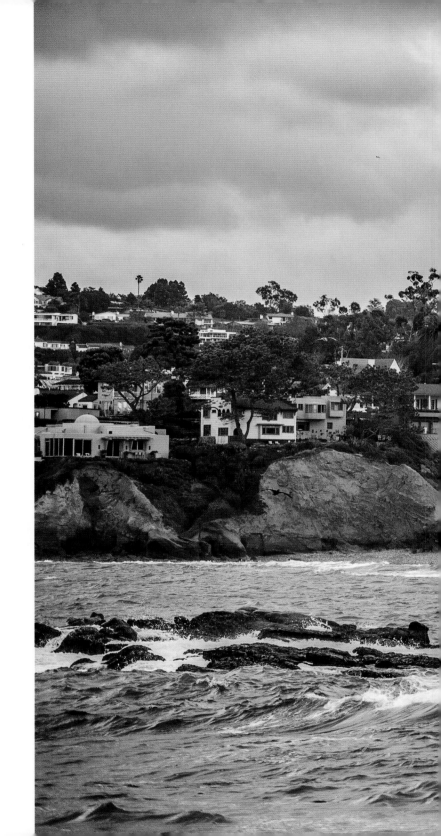

Right: A brown pelican flies overhead as sea lions, cormorants, and western gulls rest among the rocks and crashing waves at La Jolla Cove.

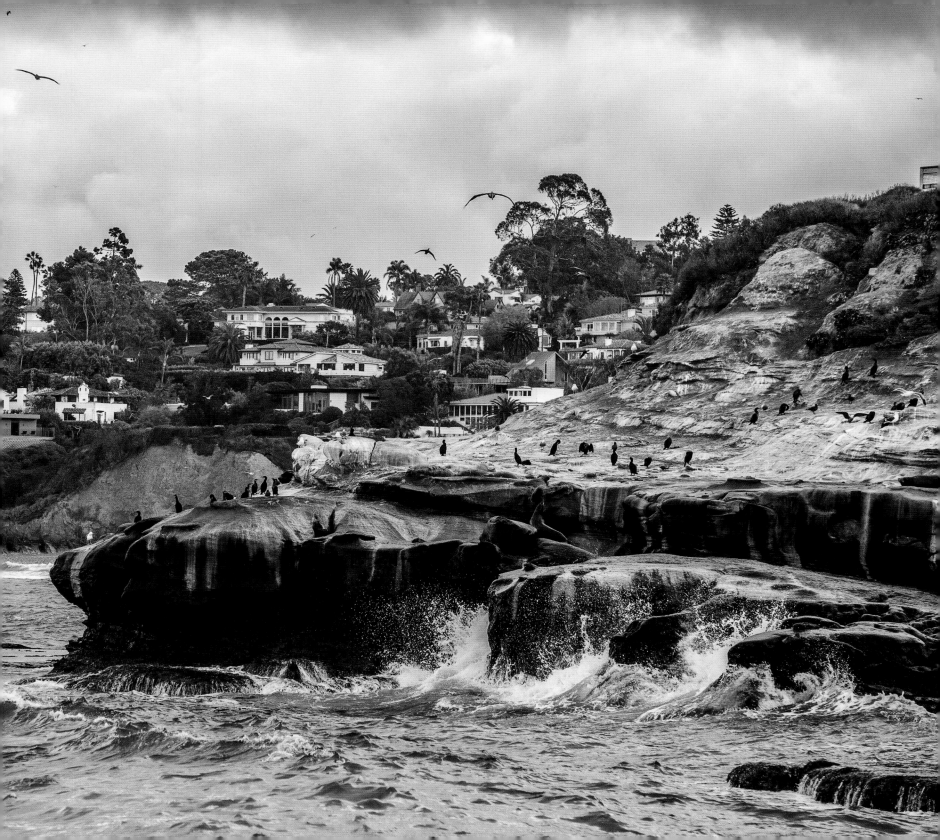

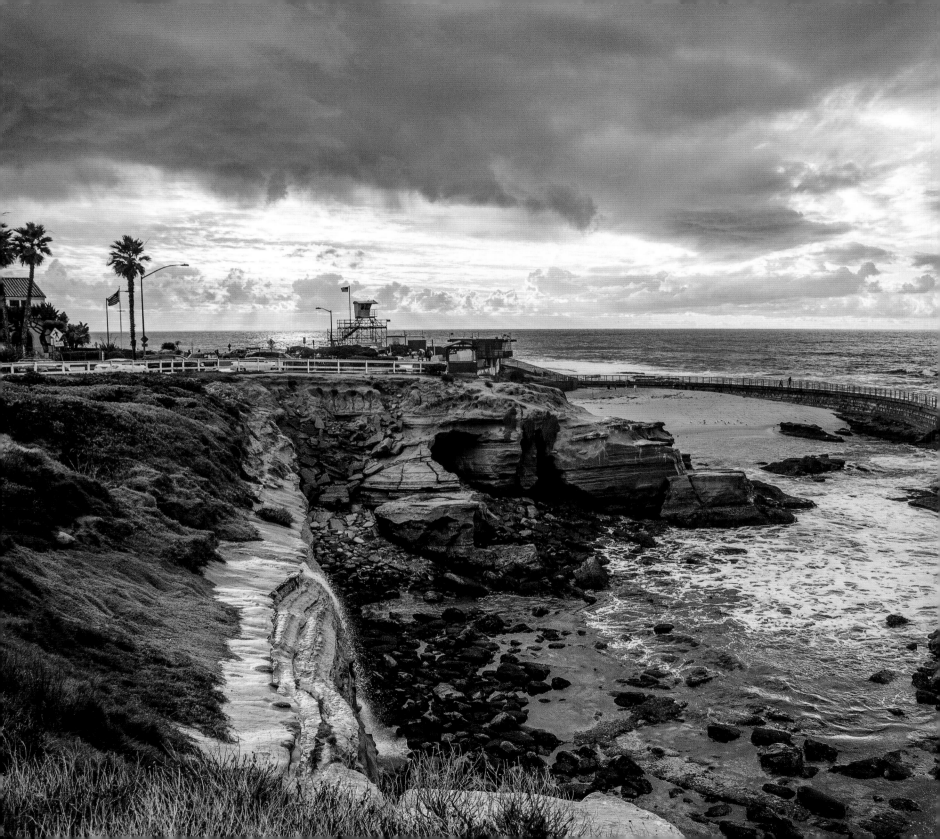

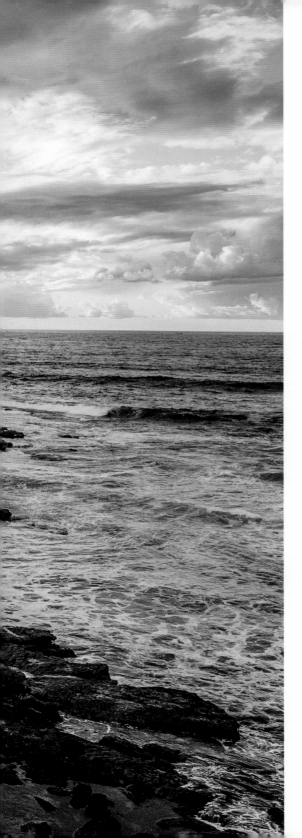

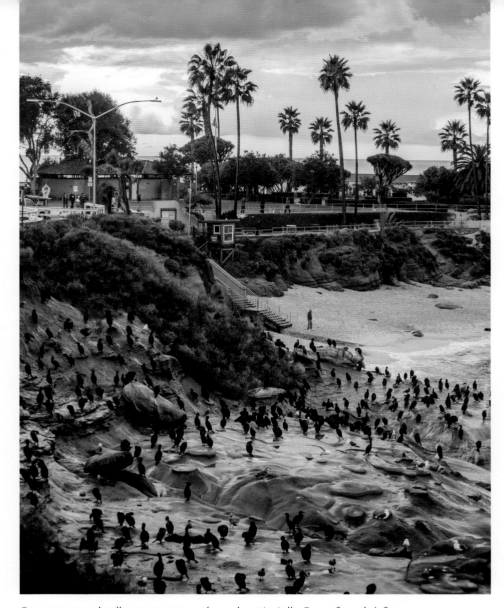

Cormorants and gulls congregate on the rocks at La Jolla Cove after a brief storm.

The curved seawall at Children's Pool provides a sheltered area for harbor seals and a typically popular vantage point for observers who have been sent scurrying by an afternoon shower.

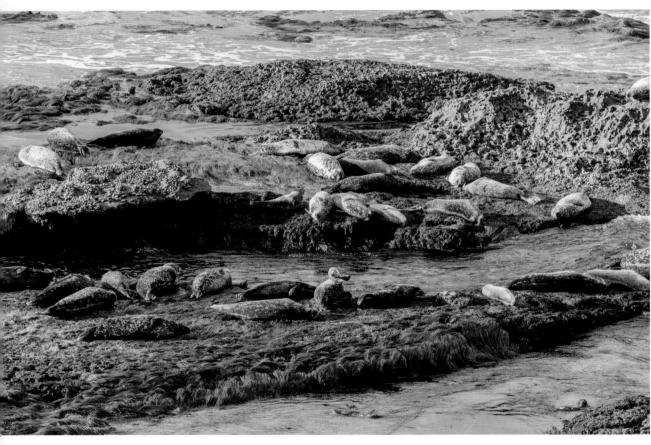

A herd of harbor seals rests on the seaweed-covered base of Seal Rock exposed during low tide.

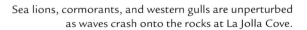

Sea lions, cormorants, and western gulls are unperturbed as waves crash onto the rocks at La Jolla Cove.

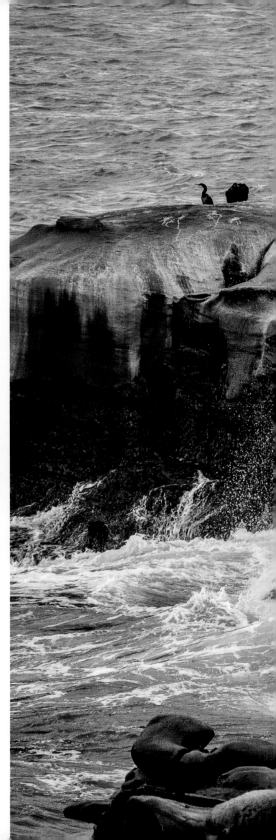

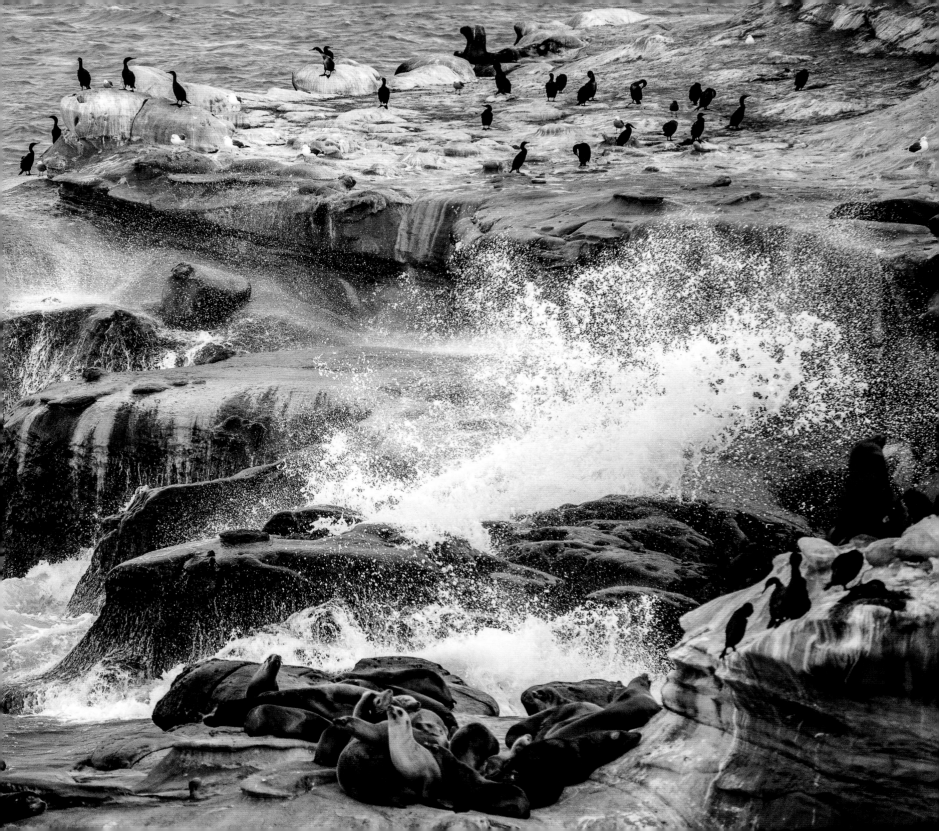

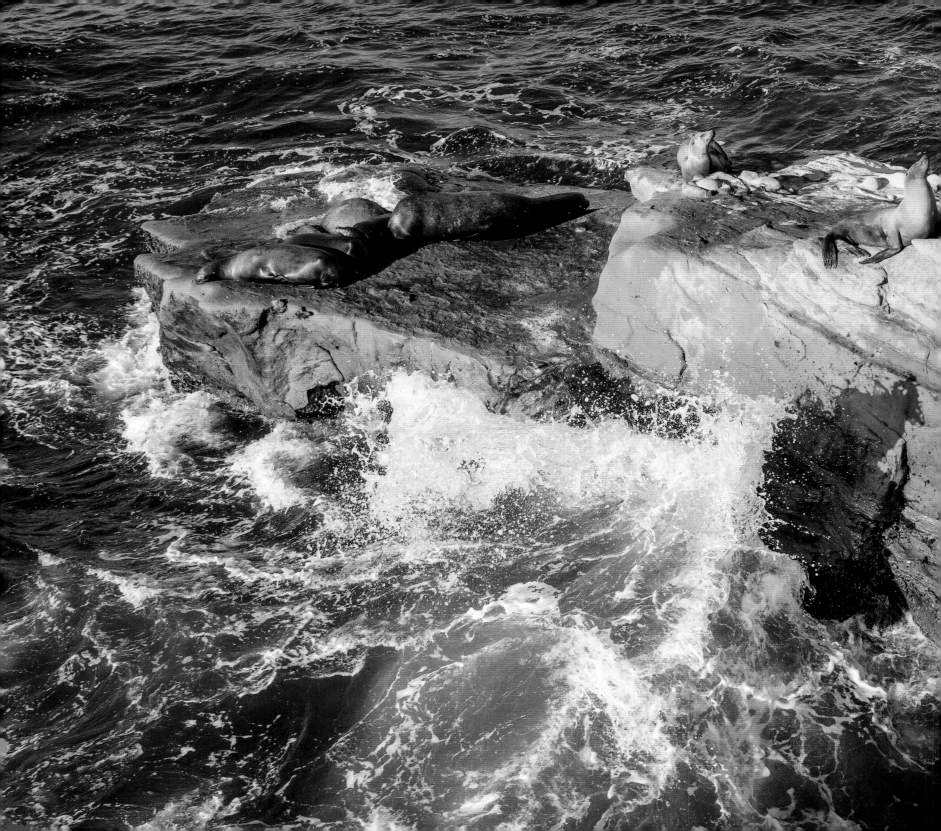

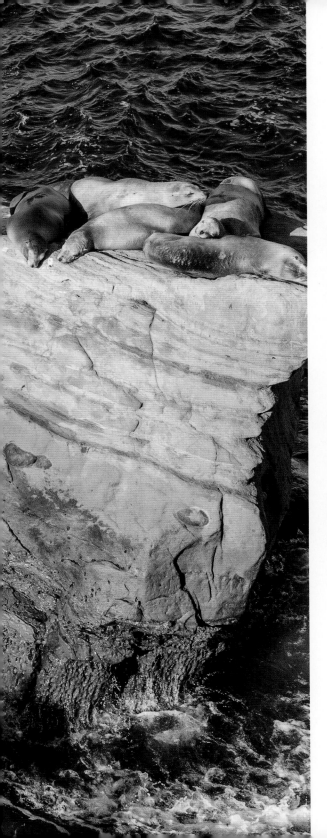

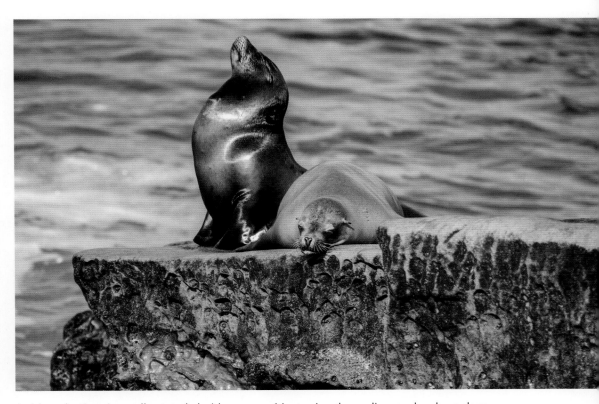

A visit to the Cove is usually rewarded with opportunities to view the sea lions and seals up close. Here, agile sea lions clamber to the top of a rock off the Cove for some sun and relaxation.

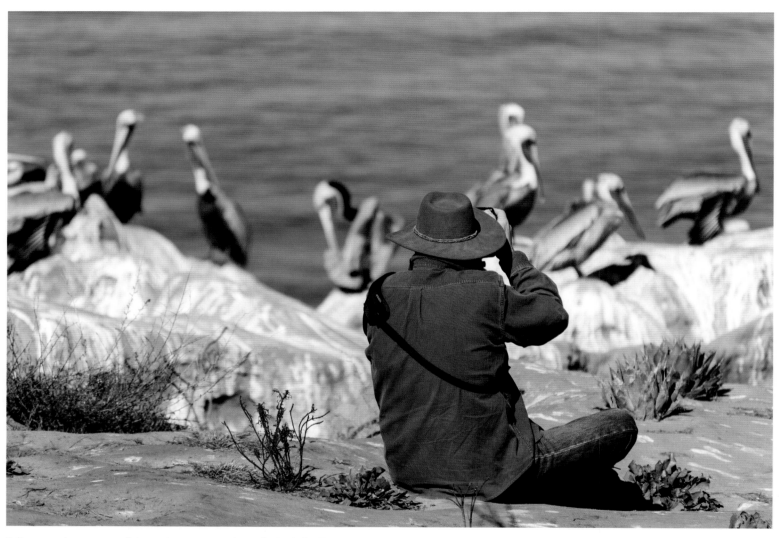

Pelicans gather on one of the rocky outcrops above the La Jolla Cave, and provide convenient subject matter for an eager nature photographer.

A brown pelican with a wingspan of up to eight feet makes soaring overhead look effortless and graceful.

98

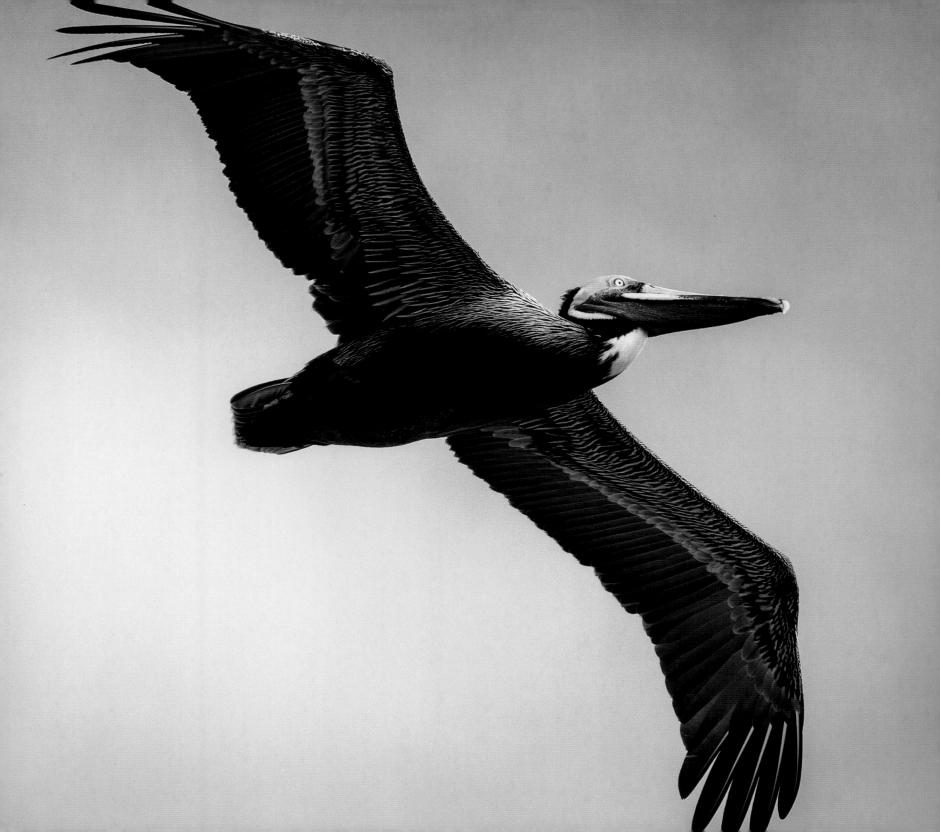

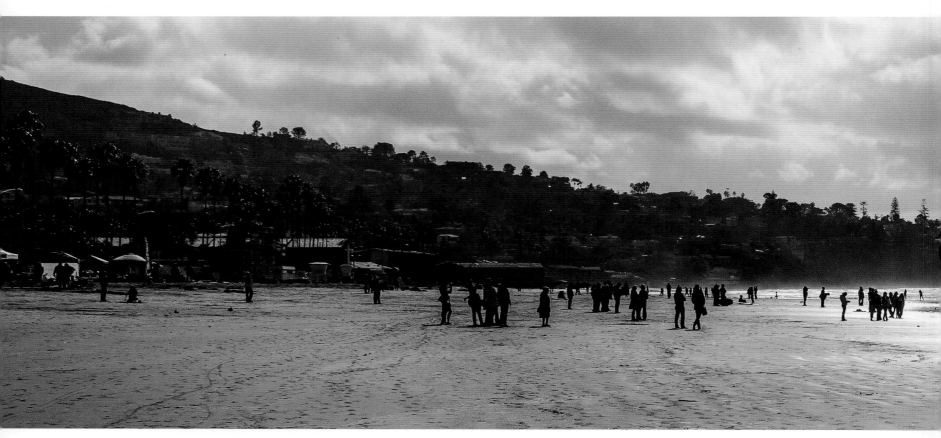

The wide expanse of La Jolla Shores Beach provides a panoramic setting to the Village in the background.

100

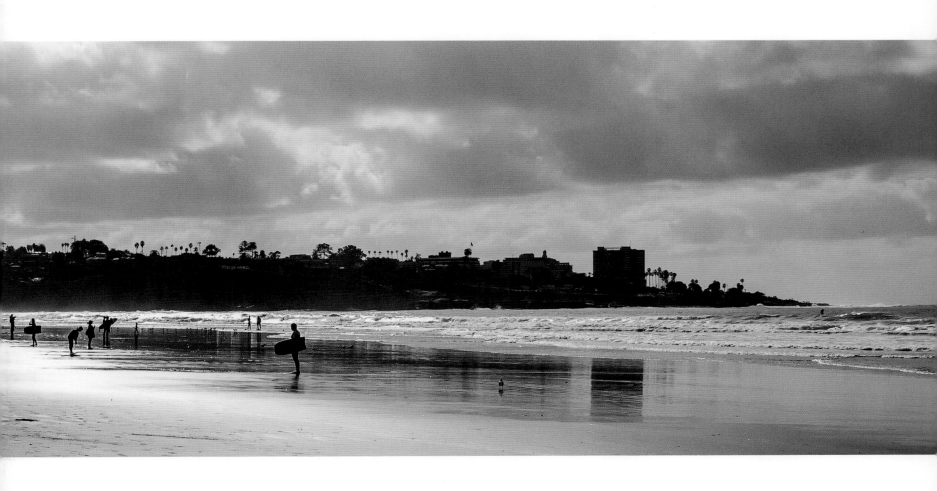

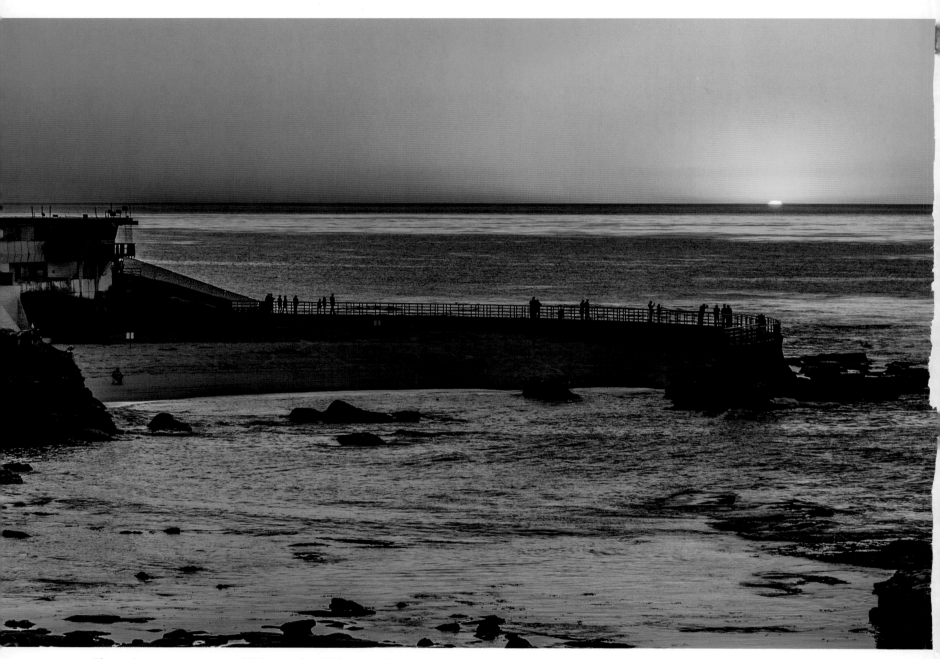

The setting sun casts a tranquil light over the Children's Pool.